Art History of
Photography

Volker Kahmen

Art History of Photography

Translated by Brian Tubb

A Studio Book
The Viking Press · New York

Fotografie als Kunst
© Verlag Ernst Wasmuth Tübingen 1973
Published in England under the title of **Photography as Art**
Translation Copyright © 1974 by Brian Tubb
All rights reserved
Published in 1974 by The Viking Press, Inc.
625 Madison Avenue, New York, N. Y. 10022
SBN 670-13437-6
Library of Congress catalog card number: 74-3703
Printed in West Germany

Contents

To Bruno Goller

on his birthday
5 November 1972

Introduction

'Art and society have a close reciprocal relationship; for the artist, who presents the work of art to society, is also a member of that society and has assimilated its needs and ideologies, to which, in processed form, he then gives expression.' This applies particularly to writers, who often use their art as a vehicle for their views. 'Yet art is one of the manifestations of social productivity which does not contribute directly to the preservation of society. It remains, therefore, almost exclusively the preoccupation of people who, by virtue of their social position and education, are able to concern themselves with things which do not directly further self-preservation. Those who commission artists have always been drawn from privileged classes. ... His (the artist's) relationship with his patrons, who provided his bread and butter and were thus the prerequisite for artistic creation, was invariably one of dependence. In order to safeguard his work prospects the artist, consciously or unconsciously, had to take into account the tastes and wishes of his employer.'[1]

And so the author's apparent freedom to write 'whatever he wants' is not worth very much. He cannot even really decide who he is writing for. Of middle-class origin himself, he is writing for a middle-class public in middle-class publications, 'the middle-class gave him, in his education, a means of production, and because of this educational privilege, he is obliged to show solidarity with that class, and it with him'.[2] The author who is aware that certain class interests are behind him and that because of this most of what he writes will tend to support the existing power structure, may still attain critical insight in contexts which have gained a political neutrality through aesthetic constraints; for art all too readily sacrifices its revolutionary potential to a semblance of autonomy.

When talking about newspapers, Siegfried Kracauer shows just how far social interests and the optical medium – here photography – condition one another.[3] 'The intention ... is to reproduce the world as it is accessible to the camera.' The pictures are 'basically ciphers which seek to promote recognition of the original'.

This recognition, however, is distorted, for 'so powerful is the effect of pictorial presentation that it is threatening to destroy any existing awareness of distinguishing features. ... The public is shown the world, but at the same time its perception of the world is falsified.'

That is the analytical view seen in relation to the public; considered in relation to the authorities the same facts present themselves in rather a different light. 'In the hands of the influential, the illustrated news medium becomes one of the most powerful weapons against knowledge. And the successful employment of this weapon is in no way hindered by the way the pictures are presented. On the contrary. For their juxtaposition systematically destroys the associations which are presented to the consciousness.' This question of 'arranged' presentation of photographic material is carried to perhaps its greatest extreme on television – though less in entertainment and educational features than in news programmes. The systematic stupefying process begins at all information sources.

From a sociological viewpoint Gisèle Freund[4] sees photography as a 'specific means of expression of the self-confident, rational-thinking, professional-bourgeois society' and, moreover, as 'an invaluable tool of this society'. For 'the attribute of precise reproduction lends it a documentary character which makes it appear the most factual and objective tool for depicting life in society'. And this illusion is worth preserving. Since photography is nothing less than objective, it is better suited than all other creative media 'to lend expression to the wishes and needs of the ruling class and to create the desired impression of its social processes'.

But the photographer, and the writer, who strive to lift their work above the humdrum and mundane in this self-same manufacturing process, face a treacherous path of critical awareness with power on the one side and powerlessness on the other.

Photography as art

This is perhaps an unfortunate heading in that it evokes the concept of artistic photography trying to imitate and compete with the achievements of 'conventional' art. 'The photographer must study the works of painters, he must train his taste, his perception, his imagination. Art-photography is a conscious approach to painting.'[5] Such were the dictates of photographic aesthetics at the turn of the century, based on a pioneering paper on the subject.[6] Little has changed in principle up to the present day, although around 1930 Walter Benjamin attempted a thorough reconsideration of the problems involved in photography. He criticized 'this fetishistic, basically anti-technical view of art which the theorists of photography have tried to use for almost a hundred years, naturally without any success. For all they have done is to place the photographer before the very tribunal that he was in the process of overthrowing.'[7] It is worth pursuing Benjamin's findings in some detail, for this book is largely indebted to his thinking.

Art as photography

In the dispute about the artistic value of photography, however, a decisive question had been overlooked: 'Had the overall nature of art changed as a result of the invention of photography?'[8] 'The emphasis certainly shifts completely when one turns from Photography as Art to Art as Photography.'[9] For 'the effect of photographic reproduction of works of art' is 'of far greater importance to the function of art than the more or less artistic composition of a photograph where the single event falls prey to the camera'.[10] Consider architecture, which is far easier to grasp in photographic form, since detailed overall and sectional views enable the eye to make comparisons and to come to the right conclusions. Art now finds itself in situations beyond the range of an original work; it is a commodity, isolated from its patron,

to be marketed according to demand. Exhibition value has grown at the cost of mystique value to such an extent that the photograph, and not only the reproduction of a painting, has found its niche – first and foremost in the book, secondly in the touring exhibition. This shift in function shook art, freed it from its fundamental cultural principles and removed its veneer of autonomy. 'The following maxim could be applied to copies of originals: rogues of a gang on one gibbet must hang. The original, instead of appearing in every reproduction, tends to disappear in its proliferation and live on as art-photography.'[11]

'With photography, the hand engaged in graphic reproduction was for the first time freed from the most important artistic obligations: these now rest with the eye alone as it looks into the lens. As the eye can see more quickly than the hand can draw, the process of graphic reproduction was so fantastically accelerated that it could keep pace with speech. ... Just as lithography was the prime force behind illustrated newspapers, so photography is the force behind the sound film.'[12] This development in technical reproduction inevitably affected the autonomy of the work of art. It was as a unique artwork that the original was granted its authenticity, its authority in the historical process. 'The unique value of the "authentic" work of art originates in a ritual where it had a real and intrinsic value. These origins are still recognizable as secularized ritual in the most profane forms of beauty-worship; ... with the secularization of art authenticity took the place of mystique value. ... When art, faced with the advent of the first truly revolutionary means of reproduction – photography – sensed the impending crisis ... it reacted with the dictum "l'art pour l'art", which is a theology of art.'[13]

Once it could be reproduced mechanically, the work of art was freed from its 'parasitic existence in ritual'. It thus became 'in ever-increasing measure the reproduction of a work of art suitable for reproducing. And since a great number of copies may be taken from the photographic plate, the request for the authentic copy is meaningless.'[14] This is true, but only when one is dealing with a number of authentic copies produced by a graphic technique such as etching. Here the required end-product is not the photographic negative, but the positive with all its specific tonal values – not necessarily even the whole of the work, but perhaps only a particular section of it. Abuse is obviously rampant, however, in the open exploitation of the legacy of leading photographers. One only has to look through different publications and compare the presentation of the same material, not to mention the so-called reprints. From a historical viewpoint, it is quite feasible for a photo-

graph to assume an intrinsic value based on the authenticity of its *raison d'être*. In this sense it is equally as vulnerable as any existing, mechanically mass-produced work of art.

What the work of art gradually loses is its aura, and photography has a crucial part to play in this. 'The need to bring things spatially and humanly "nearer" is almost an obsession today, as is the tendency to negate the unique or ephemeral quality of a given event by reproducing it photographically. There is an ever-growing compulsion to reproduce the object photographically, in close-up. ... The laying bare of the object, the eroding of its aura, is the mark of a way of perception whose "sense of the analogous in the world" is so developed that through reproduction it extracts analogies even from the unique.'[15]

Benjamin's 'definition of aura as "a unique appearance of a distance, however near it may be" is a clear formulation of the mystique value of the work of art in categories of space-time perception. Distance is the opposite of nearness. The essentially distant is the unapproachable. In fact, unapproachability is the prime quality of the mystique-picture, which by nature remains "distant, however near it may be". The nearness one can extract from one's material does not prejudice the distance which it later assumes.'[16] That the work of art, upon losing its ritual function, simultaneously sacrifices its aura, is immediately apparent; its autonomy is affected, its uniqueness too, which embeds it in tradition. Thus we have the crisis of art, created by the invention of photography, which was greeted in 1839 with the cry: 'From today painting is dead.'

Photography: art or commodity

In a law suit involving Gisèle Freund[17] the question of whether photography is art or a manufactured commodity was officially settled. In this case a picture had been illegally reproduced with the intention of selling it as an original work. In court the plaintiffs defended photography on the grounds that it was art, while the defendants rejected this. In this crucial trial of 1862 the first court rejected the charge on the grounds that photography 'was a manual operation which doubtless required skill and experience but which had nothing in common with the work of an artist who creates the work of art from nature by means of his senses and imagination'.

An appeal was lodged, and the appeal court reversed the decision. The art world then reacted by launching a new appeal which maintained that 'photography could in no way be equated with the arts since it is produced by a series of manual operations'. Ingres signed a manifesto supporting this, but Delacroix withheld his signature. However, the final judgment threw out this appeal. Moreover, it confirmed photography's status as art and thereby placed the products of the camera under the same legal protection as traditional art.

As a representative of the Academy – the institute of the conservative and traditionalist bourgeoisie – Ingres was bound to reject photography as well as naturalism: 'We do not want this industry … let it stay put and not venture near our School, the true Temple of Apollo dedicated to the art of Greece and Rome.'[18] Yet Ingres too had used photography, as is recorded in a conversation with his pupils: 'Look at this photograph, gentlemen! Who amongst you would be capable of such a likeness, of such fidelity of design, of such delicacy of form?'[19] It was this very precision which attracted Ingres to photography, and he went on to paint portraits after daguerreotypes by Nadar.[20] One has only to look at the portrait of Maria Fauquet by Nadar (1856, plate 6) which is directly reminiscent of Ingres' art.

Delacroix, on the other hand, declared himself openly in favour of photography. He was a friend of Nadar, who photographed him in 1891 (plate 9), and a member of the first French Photographic Society. His friends photographed scenes at his request, and he then worked from these photographs.[21] Yet, even for Delacroix, the photograph remained a 'remedy against the mistakes of the eye'. 'The daguerreotype is more than a tracing, it is the reflection of the object. Certain details, almost always neglected in drawings from nature, manifest their essential characteristics in the camera, and thus the artist attains a perfect knowledge of construction. In the daguerreotype, light and shade receive their true value, that is to say the correctly applicable degree of hardness and softness without which it is impossible to present objects in true perspective. But it should not be forgotten that the daguerreotype is, to a certain extent, merely a translator whose role is to instruct us more deeply in the secrets of nature. For, despite its astonishing realism in many respects, it is merely a reflection of reality, a copy, which, as it were, falsifies because of its very exactness.' But woe betide the artists 'who, instead of using the daguerreotype as an adviser – a kind of dictionary – produce their painting solely from it. They believe themselves closer to nature if they strive to corrupt the mechanically achieved result as little as possible by their painting. The unattainable perfec-

14

tion of certain effects of the metal plate is beyond them. And the more they strive to achieve it the more clearly do their weaknesses become apparent to them, and their work becomes the unavoidably faultless repetition of an – in some ways – imperfect copy, and the artist becomes a machine being led by another machine.'[22]

The artist is always concerned with a total view of the world. However, when the photographer 'takes a picture one always sees only one section removed from the whole. The edge of his picture is just as interesting as the middle; one can only guess at the existence of a whole, and the view as presented seems chosen by chance. The incidental details become just as important as the main theme – they often strike the eye first and confuse the whole. In a photographic representation one has to allow far more for shortcomings than in a work of the imagination. Photographs, which evoke a more powerful impression, owe it to the inability of the process to reproduce everything absolutely exactly. They leave certain gaps where the eye is forced to rest and which restrict the eye to a small number of details.' In art, the mind achieves this, for 'it does not observe all that the eye offers it'.[23]

Delacroix finally discusses particular photographers and their 'certain gaps'. In these are concealed the distance, and aura, of which we have spoken, and which cannot merely be the 'product of a primitive camera'. Yet even in these early days there is a direct correspondence between the object to be photographed and the technique, for the photographer was first and foremost a technician. But this changed. As Benjamin observed, 'Advanced optics soon employed instruments which completely overcame the obscurities, and produced images as faithfully as mirrors. And after 1880 photographers considered it their duty more and more to simulate this aura which the use of more light-sensitive lenses had completely eradicated from the picture, in the same way as it had been eradicated from reality through the increasing degeneration of the imperialist bourgeoisie. All the skills of retouching, especially the offset method, were put to this end.'[24] The imitation of painting reached its climax with these and similar methods around the turn of the century. Invoking Impressionism, the hardness of contour was to give way to an overall atmospheric effect, and the sharpness of the lens was artificially reduced. The 'cold, unemotional, empty likeness' was shunned and instead a 'characterization, the reflection of the being, of the soul; values which the machine by itself can never provide'[25] were sought. Edward Steichen writes in his memoirs: 'Around 1898 I mastered to some extent the skill of reproducing such moods and emotions. I was, without realizing it, an "Impressionist"' (plates 167, 168).

Progressive aesthetics had right from the start taken pains to do justice to photography without recourse to the polemics of other interested parties. At the beginning of his *Philosophy of Art* (1865),[26] which discusses the question of whether completely faithful imitation is the purpose of art, Hippolyte Taine writes: 'On the other hand ... photography is that art form which reproduces the outline and form of the object to be reproduced on a flat surface with lines and tones in the most perfect way without possibility of error. Without doubt, photography is a useful tool for the artist. It is used by both educated and intelligent people – often with taste – but it would never presume to equate itself with painting.' Photography and painting are quite separate art forms; though the function of photography as an aid to artists is attested by Delacroix and all other nineteenth-century painters. If it wanted to liberate itself from this function photography had to go its own way. Even Baudelaire, whom Carjat photographed around 1862 (plate 16) (this photo, incidentally, was used by Georges Rouault in 1927 and by Henri Matisse in 1944 as a basis for their portraits of the poet),[27] held the same view: 'Photography is quite at liberty to adopt the ephemera which are entitled "to a place in the archives of our memory", as long as it stops short of the "confines of the intangible and the imaginative" – short of the confines of art in which there is only a place for that "to which man gives his soul".'[28] Yet in his review of the Salon of 1859[29] Baudelaire had attacked photography as a 'refuge for all failed painters'; he satirically celebrated it as the absolute art: 'In these regrettable times a new industry has emerged which contributes not a little to consolidating the stupidity in today's beliefs and to destroying what remains of the "divine" in the French spirit. ... I believe in nature. I believe that art exists only in the exact reproduction of nature· Thus the "industry" which can give us an identical copy of nature is the absolute art. ... An avenger of God granted the wishes of this people; Daguerre became its Messiah. Whereupon the people said, "If photography can give us all desirable guarantees of exactness, then photography is art."'

At the time photography was invented art was undergoing a change in direction. With the development of the capitalist economic system, which conditioned the evolution of industry as well as the progress of the natural sciences, a new awareness of reality inevitably became apparent in man's thinking. Positivism saw nature in the new light of scientific precision, which demanded objectivity. The most progressive artists, guided by this formula, favoured al fresco painting and a faithful reproduction of a landscape with the emphasis on clarity. But 'as soon as Daguerre

16

had successfully fixed camera obscura pictures, painters were unceremoniously ousted by the technicians.'[30] The bourgeois painting of the *juste-milieu* rose to fame simply because it was able to equal the daguerreotype in terms of realism. When the ideals of this school were dramatically shattered by photography, its adherents gloomily prophesied the death of painting.

Around the middle of the century, the Realists began to react against Romantic tendencies in art, asserting that 'one can only paint what one sees'. The artist should face nature objectively, that is to say, impersonally. For, since nature is in itself aesthetic, it does not need the intervention of the artist. Thus the optical reality coincides with the true reality of nature. The artist, as a craftsman, should withdraw behind his work.

This sounds very much like the ideological criterion of the concerned photographer. Yet for the Realists the scientific products of photography could never be a true interpretation of art. 'On the contrary, photography will help the artist to rise above the purely mechanical copying of objects.'[31] This statement also reflects the views of the naturalistic artist; Zola, for example, who was also involved in photography (plate 67), saw in the photograph enormous potential for broadening one's powers of observation, but felt it could make no claim to being art: 'In my view you cannot claim to have really seen something until you have photographed it – it brings a whole host of details to the fore which would otherwise have remained unnoticed and which would have been in the main impossible to discern.'[32]

Gustave Courbet, a leading member of the Realist movement, also made use of photography, as in the case of his portrait of Proudhon in 1865.[33] In spite of the realistic point of departure, this is still indebted to idealistic transposition and accordingly sacrifices factual content. This contrasts with Nadar's achievement in his portrait of the same man in 1853 (plate 22). As Benjamin pointed out, with Courbet, the usual relationship between painter and photographer was, for a certain period, reversed. 'His famous picture *The Wave* resembles the discovery of a photographic subject through painting. Neither the close-up nor the snapshot were used in Courbet's day: his painting shows the way. ... Courbet's particular strength lies in the fact that he was the last to try to outstrip photography. His successors tried to run away from it – first and foremost the Impressionists. Since the painted picture avoids the mechanics of drawing, it withdraws to a certain extent from competition with the camera. There were attempts in photography at the turn of the century to turn the tables and imitate the Impressionists – by using offset printing.'[34] 'When

17

Impressionism, which developed the use of chromatic elements in painting, gave way to Cubism, painting had created a further domain into which photography, initially, could not follow.'[35] But the attempt was soon made, as can be seen in A.L. Coburn's portrait of Ezra Pound (1916, plate 258).

Photography in the nineteenth century

The most progressive artists, however, were concerned right from the start (and this situation has not altered) with the question of photography's artistic value. As a visual archive, it was far easier to manipulate than works of art, or even nature itself, and the enormous extent to which photographs were used as bases for works of art has been explored in various studies:[36] these reveal names such as Corot, Manet, Degas, Cézanne, Gauguin, Toulouse-Lautrec, Rousseau, Picasso up to Warhol, Rauschenberg, Bacon and Hamilton. One could, in fact, list every artist since the invention of photography, for its influence may, to some extent, be seen in the work of each of them.

Camille Corot probably did not himself take photographs, but he experimented around 1853 with so-called 'glassprints'. In these a design was introduced on to layered glass plates with a needle, and from these negatives any number of copies could be made on light-sensitive paper.[37] Corot was also a friend of the photographer Adalbert Cuvelier, and they worked together from nature in the district around Arras (plate 32). Corot's influence is evident in the atmospheric haziness of this landscape which captures the movement of wind in the trees, and which is obviously indebted to a romantic naturalism. Gustave LeGray demonstrated his realist conscience with 'Fontainebleau Wood' (1856, plate 33). Economic pressures had compelled him to abandon painting for photography, and in 1851 he had even found a way to improve considerably the paper negative. Henri Victor Regnault's landscapes (plate 31) show the objectivity of a scientist (he was a professor of chemistry and director of the porcelain works at Sèvres) yet the 'aura' of his works cannot be disputed. This was not the case, however, with the revolutionary realism of Eugène Atget's photographs (plate 34). Here even the landscape has lost the innocence and the impressionist magic which could still be seen in Fox Talbot's 'Pencil of Nature' (plate 35), Froissard's 'Flooding of Lyon' (plate 36) or Bayard's

views of Paris (plates 28, 29). Like Atget, August Sander (plate 5) then liberated his pictures from that aura which, as with David Octavius Hill (plates 3, 4), conveyed man's security in his own environment. What makes these last pictures unique is their innate grace; it was only a little later that Lewis Carroll (plate 2) showed the first signs of an increasing alienation.

Edgar Degas, one of the most important artists of his time, took photographs himself (plates 8, 13), but not with the intention of working from them. They are works of art in their own right. Yet Degas assiduously studied Eadweard Muybridge's action-pictures and regarded his *Animal Locomotion* of 1887 as a standard reference work on movement. He produced his studies of horses with its help, since such precise observation was not possible from nature. Muybridge (plates 49, 146, 342) had developed a system using (usually) twelve cameras side by side in such a way that the movement of the subject could be discerned in the resulting photographs: the camera shutters were automatically triggered one after another by electrical impulses. Although his picture series may be regarded as the true forerunner of the motion picture, Muybridge was concerned primarily with the systematic study of the movement of animals and men, and felt himself to be a scientist, not an artist.

It was a different matter with the painter Thomas Eakins who started taking photographs in 1880 with the intention of using them as a basis for his pictures (plate 55).[38] He regarded certain shots as having potential for graphic art (plates 71, 265); but his most interesting photographs are motion analyses (plates 50, 51, 52) which must have been prompted by his contact with Muybridge, whose work he had been able to support thanks to some of his personal contacts. Eakins considerably intensified the impression of movement by using only a single camera which enabled him to take a quantity of superimposed single shots simultaneously.

In portraiture the photograph is clearly superior to painting when an accurate likeness is wanted, and painters often use photographs as models for their portraits. In 1843, when the English painter David Octavius Hill was commissioned to paint a group picture of the 470 delegates of the inaugural assembly of the Free Church of Scotland, he immediately enlisted the services of the young photographer Robert Adamson to help produce the prototypes for his painting. And it is the photographic portraits he produced with Adamson (plates 10, 11, 12) – 'merely aids, only for personal use – which have assured him a place in history, while he is forgotten as a painter. It is worth noting, however, that some of his anonymous figure studies

(plate 42) offer more insight into the new technology than his series of portrait heads. … Paintings only survive as witnesses to the art of the man who painted them. But with photography one is confronted with something new and strange: in the fishwife from Newhaven (plate 59), lowering her gaze so coolly and seductively, there is an indefinable quality which bears no relation to the photographer, Hill; this quality which will never fully be explained by all the normal criteria of art eloquently exhorts us to find out the name of this woman who once lived, who is still very much here.'[39] This quality is in a captured moment of time past, for space and time survive in photography, though not in the same way that they do in memory. For 'this most exact technique can lend its creations a magical quality which may no longer be present in a painted picture. Despite the evident skill of the photographer and the care taken in the sitter's pose, the viewer feels the irresistible urge to seek in such a picture the merest hint of chance, of the here-and-now, with which reality has, as it were, branded the character of the picture – to find that insignificant detail in which, in the arbitrariness of the long-vanished moment, the future so eloquently nestles even today, so that we, looking back, may discover it.'[40]

This sensation of suspended time is even present in Lartigue's childhood snapshots of Paris, taken at the same time as Atget was depicting the same city, though in a far more sophisticated, and alienated, way. Jacques Henri Lartigue started taking photographs around the age of eight, and when, aged eighteen, he decided to study painting, his contribution to art ended. As a child he had artlessly recorded things that were important to him – almost entirely concentrating on the world of grown-ups (plates 56, 57, 58, 98, 99, 104). All his subjects are photographed in motion; their facial expressions cannot be seen, and a veil often obscures their features; and yet this fleeting restlessness is very much concerned with reality in an impersonalized world. Although the child may only have been indulging his own love of fast-moving objects, his photographs preserve that 'long-vanished moment', filled with melancholy.

It was by no means coincidental that early photography concentrated so much on portraits, for it was here that the mystique value of art made its last stand. 'In the cult of recalling distant or deceased loves the mystique value of the painting finds its final refuge. The aura in the fleeting expression of a human face in the early days of photography … is that which gives it its melancholy and incomparable beauty.'[41] The pictures by Nadar (plates 6, 9, 22), Carjat (plate 16) and Brady (plates 15, 17,

20

18) bear witness to this aura which lends the face of the subject its determination and strength. It is the face, and the expression on it, which bring the picture to life: though the face is certainly directed towards the camera, a certain shyness of the photographic equipment keeps these early sitters distant and reserved. 'The eyes gazed out of the stillness of the face.' Many of Hill's pictures were taken at the Greyfriars Cemetery in Edinburgh – a place of utmost solitude where nothing interrupted the state of quiet contemplation. And the minimal light-sensitivity of the plates demanded a long exposure in the open. So it was the technical process which caused the subjects 'to exist not outside the moment but within it; during the long exposure period they grew, as it were, into the picture, thereby providing a striking contrast with the results of quick exposures'.[42] In Hill's work this long exposure period effected a progressive growth of light from darkness. This technique gave rise to the quality of 'aura' in Hill's work (plates 4, 12); Julia Margaret Cameron (plate 81) tried to achieve this same effect by using faulty lenses. Degas (plates 8, 13), using his artistic knowledge, produced this aura by means of his lighting techniques; but aura can be equally well achieved by an anonymous layman, as in the photograph (plate 84) of Rodin and his wife on their wedding day, 29 January 1917. The hand of death is already upon them, and, indeed, they both died that same year.

'Everything about these early pictures was intended to last; not only those incomparable group poses (plates 23, 26, 142) (whose disappearance was surely symptomatic of the way society developed in the second half of the century) – even the folds of the dresses have a quality of permanence. Take, for example, Schelling's coat (plate 14), which will surely pass into immortality; the lines it assumes on its wearer are every bit as interesting as the lines on his face.'[43] Moreover, at that time the photographer was as much at ease with his technique as he was with his bourgeois clients. The aura was omnipresent and interwoven with the surroundings – even down to the drapery of the frock-coat. There was no need for props to give the scene added weight. Around 1850 the photographer was at the same evolutionary stage as his equipment, and this precluded him from belonging to the avant-garde. As it grew as a social force, the bourgeoisie too developed a need for pictorial representation. This need, as always, could satisfactorily be met by the portrait. Long before the invention of photography there had been many attempts to replace the costly ivory miniature with quicker and cheaper substitutes, and when these were perfected portraits became available to a much wider public. But when Daguerre introduced his exposed silver plates with their delicate grey pictures, the position

of the miniaturists was seriously threatened. The result of this was that by 1840 most of them had become professional photographers. One of these was Carl Ferdinand Stelzner of Hamburg (plates 20, 26): in his daguerreotype shown in plate 19 he points a most eloquent contrast in the widow sitting next to the painted portrait of her late husband. All over the world, professional photographers were demonstrating how artistically superior early photography was to the portrait miniature (plates 74, 75). But with the increasing popularity of the photographic portrait there came, inevitably, a decline in 'aura'. 'The element of impersonality, or rather immortality, in the daguerreotype derived from the sitter's continuous gazing into the camera during the taking of the picture, without this gaze being in any way returned by the camera. Anticipation is inherent in this gaze, and is returned by the viewer. When this anticipation is returned ... the presence of the aura strikes him, with all its implications ... to experience the aura of a figure is to invest it with the power to open its eyes.'[44] But when it will not, when life disappears behind the shelter of a costume, then we experience an uncomfortable chill (plate 77).

But technical development advanced: optics were improved so that exposure times were reduced, and the silver plate was superseded by the glass negative from which any number of copies could be made. The portrait thus achieved an unprecedented popularity which had a tremendously democratizing effect, for in the photograph all class barriers were removed. 'Proust's observation – that the photographs of the grandfathers of a duke and a Jew look so alike that one no longer considers the social hierarchy involved – makes a more universally valid point: all the points of dissimilarity which dictate the fortune – even the moral fibre – of the individual existence, disappear objectively behind the uniformity of an epoch.'[45]

As painters had once sought to tread a middle path of realism in their portraits while paying heed to the dominant characteristic of their clients, so now did photographers, when they had increased their circle of clients and reduced the picture format to that of Disderi's *carte de visite*. They chose representative poses, so that the whole form could now be seen, and they scattered the surrounding area with symbolic props. The client found himself playing the part of an actor in the professional role he had selected. The social aim behind this, of course, was to establish incontrovertibly the middle-class status of the sitter. And so the background paraphernalia of famous paintings – drapes and pillars – found its way into the photographic studio as evidence of an artistic milieu (plate 39). But photographers soon became critical of this set-up. 'In paintings the pillar has some semblance of credi-

bility, but in the photograph, where it is usually represented on a tapestry, it looks absurd.'[46] When retouching, 'with which bad painters took their revenge on photography'[47] became customary (plate 21), and those with an eye for business put the colour photo on the market as a substitute for painting, the artistic decay of photography was finally confirmed. The proliferation of amateur photographers dealt a final blow to the professionals when, in 1888, Kodak announced: 'You press the button, we do the rest.' Technology had taken over: department store photobooths were later to mass-produce automatically the obligatory passport photo.

In the first few decades before industrial exploitation set in photography enjoyed a high artistic status which guaranteed it a novelty value with the avant-garde. Interest was centred entirely on striking (often sensational) images, offered in the form of matter-of-fact reportage – in foreign lands (plate 37), of abnormalities (plate 38), in asylums and boarding-schools (plates 45, 46, 47, 48), in areas of social deprivation (plates 41, 44), in science (plate 317), of architectural constructions (plates 208, 209, 213), or in catastrophes and wars (plates 110, 111, 112, 113, 114, 115). Around 1860, Nadar, who had already done some aerial photography, took photographs in the Paris sewers using artificial lighting (plate 86). The documentation of an as yet not completely alienated environment was a stimulating brief for these photographers even though, with the march of time, the signs of alienation became increasingly apparent. For Fox Talbot (plate 94) there was still the music of the harp; the windmill still turned (plate 93); there was still a feeling for the comfort and security of things, as in the way the shadowy hand reaches out protectively to the young Prince Arthur on his pedestal (plate 40). Later, the musical instruments become mere props clutched awkwardly, without pleasure (plates 60, 61). In Lewis Carroll's photographs (plates 62, 63, 64, 66) each child introduces her own props and style of dress into the scene which has been arranged for her. The melancholy of the little girls lend them an erotic fascination, not only experienced by the photographer. The aura has almost faded; a fact which is not least evident in the oval format which attempts to impose from without an atmosphere of cosy subjectivity. The aura begins to disappear from every object – every chair suddenly becomes menacing. More evidence of a changing world can be seen in the almost terrifying picture of the Spanish couple (plate 79), who seem to be arresting their child rather than holding him, and would appear, together with the cock, to be more at home sacrificing at an altar than demonstrating the future height of their son. The way their eyes stare past the camera (only the child deigns it a glance) under-

lines this menacing alienation. The suffragette at the controls of her aeroplane (plate 97) looks even more grotesque, if one can ignore for a moment the humour of the situation – ensnared by the network of mechanical apparatus she looks more like the captured fly than the spider. Houses, by the latter part of the century, present a hostile façade (plates 89, 150), and their occupants emerge only with some hesitance (plate 88). Atget's railings seem to hold the house-front prisoner (plate 96), and the inmates press their faces to the panes as if all possibility of escape is gone. There is an uncanny magic in such pictures, and living creatures in them are placed under a surreal spell, a spell of alienation (plate 91). However, when Rejlander aims deliberately at this magical effect by printing two under-exposed plates one over the other (plate 90), the result falls short of Atget's creation (plate 92), which achieves a successful synthesis of the shop-window and the reflection of outside reality. The propensity towards non-realism is inherent in all photography which is more or less consciously aping art, and the result is all too often kitsch. Take, for instance, Dante Gabriel Rossetti's photograph of Jane Morris, one of his sitters (plate 68), or the triptych-like composition 'Spring' by Clarence H. White (plate 69), or the Edward Steichen photographs (plates 167, 168). Where White managed to avoid this tendency (plates 70, 73), he achieves an aura of childlike naïveté in which he is, momentarily, in sympathy with his environment.

'The more subjectivity was questioned in painting and graphics in the light of new technical and sociological realism',[48] the more photography was bound to increase in importance, thanks to its ability to produce unbiased, objective evidence. Those bitter squabbles over the relationship of art and photography could only have arisen out of rival interests, for whole sections of industry had eventually collapsed as a result of its invention. Photography had systematically turned every possible area of visual perception into a saleable commodity. 'To increase turnover they adopted new techniques suited to current fashions and this determined the future of photography.'[49] The pioneer work was done; a 'general inventory of nature reduced to the smallest possible proportions' projected as an 'omnibus catalogue of all manifestations present in nature'.[50]

Photography's claim to be art was upheld as soon as it became big business – that is to say a saleable commodity. The dialectical irony of this fact was commented upon by Walter Benjamin: 'The process which was later to call into question the term "work of art" by promoting its availability by reproduction, is clearly itself an artistic one.'[51]

24

Erosion of the aura

'When the human aspect is removed from the photograph, representative value begins to take precedence over mystique value. For this development we have to thank the unique contribution of Atget, who portrayed deserted Paris streets around the turn of the century.'[52] For Atget it is the display of goods (plate 129) or the temptations of the shop-window (plates 92, 126, 132) which reflect human activity; clothing appears for the first time as a mere commodity (plate 134). And when here and there people appear, they are scarcely presented as individuals – more as prototypes of an alienated commercial world, as for instance the umbrella vendor (plate 128) or the tart in the doorway of her sleazy apartment (plate 127). People as vendors of themselves, presented like goods, are also seen in the pictures of prostitutes taken by a professional photographer, E.J. Bellocq, around 1912 in New Orleans (plates 53, 65, 135, 175, 176, 177). The naked precision of these photos, reflecting an absolute involvement with his subject, may be compared with Atget's vision – for here too the aura of both man and object is eroded in favour of representative value.

'Atget's Parisian photos are the forerunners of surrealistic photography (plates 92, 119, 134); ... he is the first to disinfect the cloying atmosphere created by conventional portrait photography of the decadent era. He cleanses – even purifies – this atmosphere.'[53] The streets and yards are empty. 'They are not desolate, merely expressionless; in these pictures the town has been cleared, just like an empty house awaiting a new tenant.'[54] Atget photographed Paris as if it were the scene of a crime (plate 85). 'Even the scene of the crime is deserted. His picture is part of the circumstantial evidence. Atget's pictures begin to take on the role of documents in a historical trial. That is their hidden political significance. They demand to be viewed in a particular way. They are not really suitable material for superficial contemplation. They disturb the viewer – he feels that he has to find the right way to approach them.'[55] Here we are offered a wholesome alienation between man and environment 'which clears the way for the politically trained eye, which waives all intimacy in favour of highlighting the detail'.[56] This objective view of an alien environment is the triumph of progressive photography around 1910 (plates 125, 136).

An analogy with Atget may be seen in the pictorial world of August Sander,

though he is less interested in the alienated environment than the people who populate it. He is no longer concerned with individual portraits; for him human faces take on an archetypal significance. And his approach whether in a sociological (plate 1) or anthropological guise (plate 340), is always scientific. Döblin writes in his introduction to *Antlitz der Zeit (Face of Time)*:[57] 'Just as man first came to an understanding of nature and the working of the organs through a study of comparative anatomy, so this photographer has promoted comparative photography and asserted a scientific stand against the detail-orientated photographers.' And in 1931 Benjamin[58] urged the publishers to release more of 'this extraordinary collection'. 'Works of this kind could assume an unimagined topicality overnight. The power shifts to which we have become accustomed have elevated the process of improvement and refinement of physiognomic interpretation to a level of vital necessity.... Sander's work is more than a picture-book: it is a training manual' – which in 1934 was confiscated and destroyed.

The complete work, which had been offered for sale on subscription since 1930, was 'arranged in seven sections, corresponding to the existing social order, to be published in forty-five portfolios of twelve photographs each. Starting with the peasant (plates 5, 83, 145), Sander leads the observer through all the social classes (plates 1, 139, 148) and professions (plates 144, 228).'[59] It was not so much the economic situation, as Benjamin had feared, but the political one, which blighted the realization of this great scheme: Sander was eventually equated with the 'degenerate artist', and forbidden to work. Today, after careful elimination of all nonessentials, a prudent reconstruction of the complete work – from the bewildering array of the extant photographic material – would be a prerequisite for a full understanding of Sander's achievement. The distance which Sander maintains from his subject while at the same time identifying with it, draws from each individual his own aura, and compensates him with an archetypal, visual strength which remains unique in photography. This contrasts very clearly with, for example, a photograph like that of Chagall and his young daughter (plate 138) in which personal aura is erotically interwoven in the disturbing confrontation between naked and clothed.

The pictorial world of Diane Arbus, which is reminiscent of Sander, is more concerned with the anecdotal, with man on the sidelines or as an outsider, whether as a twin (plate 78) – compare Sander's peasant girls (plate 5) – or in a nudist camp (plate 206) or on Fifth Avenue (plate 82). Diane Arbus found her true milieu in what August Sander described as 'the outsiders'. A sense of anxiety is evident in

26

much of her work (plate 140), and this may be intensified by a bluntly descriptive title: 'A young family in Brooklyn going for a Sunday outing. Their baby is named Dawn. Their son is retarded' (plate 27), or: 'This is Eddie Carmel, a Jewish giant, with his parents in the living-room of their home in the Bronx, New York, 1970' (plate 80). In Diane Arbus' work the apparently unassailable family union (plates 24, 25) is undermined by the disquieting intrusion of the unexpected. Yet because they are exceptional her subjects, though shocking, remain part of a fairy-tale, unreal world. The observer mentally pushes what he sees back towards the sidelines of his existence, where Diane Arbus originally found it.

The artistic avant-garde were quick to exploit the new process of photo-montage, through which they hoped to instil a revolutionary energy into the factual content of their creations. 'A section of a photograph would be pasted on to a painting (plates 118, 182, 183, 238); or something would be drawn or painted on to a photograph (plates 241, 244).'[60] The effect was to destroy illusion, for 'the assembled elements serve to disrupt the continuity in which they are assembled'.[61] The Cubists, and later the Dadaists, achieved in their collages 'an indiscriminate annihilation of the initial aura of their creation, on to which they imposed, by using the tools of production, the stigma of reproduction'.[62] This disruptive alienation effect has an immediate titillating quality, but then dissipates into a stylized functionalism. It may be seen in the tendency to give captions 'without which all photographic construction must founder in its nonspecificity'.[63] For this reason August Sander captioned each of his photographs, according to group and genre, as well as giving them a specific name which alluded to the conception as a whole. And Walter Benjamin insists: 'We must ask the photographer to give his picture a title which will raise it above the urbane and lend it a revolutionary, practical value'; for 'the best intentions are wasted if one is not given the means to appreciate them'.[64]

In John Heartfield's photo-montages we have a perfect example of 'the importance of the caption which, like a fuse, leads the critical sparks towards the pictorial explosive'[65] and thereby guarantees its 'social penetrating power': 'Subjects' (plate 149), 'To the Depression-Party Conference of the S.P.D., 15.6.1931' (plate 153), and (plate 154):

'I am a cabbage-head – see my leaves!
Of care I know nothing at all,
Yet I stand still and pray for a Saviour –
I want to be a black-red-golden cabbage-head, that's all!

I don't want to look and I don't want to hear,
Nor meddle in affairs of state
And even if you strip me down to my shirt
No Commie rag will ever get past my gate!'

Many politically provocative photographs incorporate words (plates 152, 158). They also tend to make use of mass displays of power. The ornamental use of masses (plates 151, 156, 157) can be particularly effective for, 'in general, mass movements present themselves more clearly to the camera than to the eye. ... This means that mass movements, including war (plate 155), are a particularly convenient form of human activity as far as the photographer is concerned.'[66] One must not forget, however, that the photographer can also contribute to the aestheticizing of war (plate 290), and politics (plate 160).

In an article on photography written on the occasion of the 1855 World Exhibition[67] Antoine Wiertz, a 'boorish painter of ideas', made the prophetic statement: 'Do not believe that the daguerreotype will kill art. ... When the daguerreotype – this little giant – has grown up, when all its art and power have developed, then the Spirit will suddenly lay a hand on its shoulder and cry, "Come here! Now you belong to me! We will work together."' This prophecy was first fulfilled with photo-montage (plates 186, 188, 239, 334, 341, 353). But the artistic device of interruption or alienation is not only found in photo-montage. It can arise simply from the subject matter itself, as long as there is an alienation between subject and object, whether by chance (plates 116, 117, 211, 216), by manipulation (plates 106, 189, 190, 192) or by associative contrast, as in pictures with a plastic, Picasso-esque quality (plate 191), or in Bellmer's dolls (plates 178–181). Here the functional context always determines how long the sense of anxiety lasts; it disappears, for example, very much more quickly in Les Krims' productions (plates 200, 201) than in the anonymous medical photo (plate 202). Further possibilities of the same stylistic approach are the detail (plate 130) and the comparison (plates 162, 361/362, 365/366). (Comparison was the determining factor in the lay-out of the picture section of this book, in an attempt to demonstrate that critical understanding is made possible by means of direct visual observation.)

The world is beautiful

The more photography becomes divorced from the objective world the more creative it considers itself in submitting reality to a metaphysical transfiguration; aesthetic pleasure becomes the be-all-and-end-all (plates 123, 124). And when a gesture of this new objectivity challenges conventional understanding, the 'bourgeois credo' is revealed in titles like 'Sunday paper' (plate 170) or 'Happy boxes' (plate 171). 'The more the crisis in today's social order takes hold, and the more stubbornly its individual features confront one another in stark contrast, the more the creative element – in the profoundest sense a hybrid: contradiction is its father, and imitation is its mother – has become a fetish, the manifestations of which finally owe their existence only to developments in fashionable lighting techniques. The creative element in photography becomes its surrender to fashion. The world is beautiful – that is its slogan. It represents an attitude to photography which glorifies every soup-tin but which is incapable of placing it in its human context; and its fanciful themes are more a symptom of its saleability than its wisdom.'[68] Kracauer put it like this: 'Photographic artists operate within those social areas which are concerned with a veneer of spirituality because they fear the true spirit. ...'[69] But this sort of attitude still more or less determines the aesthetic conscience of photography, though naturally in a somewhat modified form and with a few refining nuances (plates 72, 187, 193, 288–300). Duane Michals' sequences also subscribe to this approach, for paradise can certainly not be regained by means of a striptease and a few rubber-plants (plate 207). Elliot Erwitt at least prompted a few smiles with the comic situations of his world (plates 103, 105, 164). But the comic monuments dispassionately photographed by Edward Weston are far less innocent, and we suppress our smiles when faced with such manifestations of an alienated environment (plates 217, 220).

But this type of photography has found its real niche in the world of fashion, of advertising propaganda, where its achievements are often highly impressive (plates 165, 169, 172, 173, 174, 185). Kitsch in advertising glorifies the consumer world for commercial purposes, but at the same time it betrays it. But that is the exception: disguised as *Neue Sachlichkeit* (new objectivity) photography can succeed 'in making even misery an object of delight, by presenting it in a fashionably idealized way'. 'For if it is an economic function of photography to put before the public

places, people and situations, which were once beyond their experience, so it is one of its political functions to present the world fashionably.'[70] Brecht said: 'The situation is becoming so complicated that a simple "reproduction of reality" says less than ever about reality. A photo of the Krupp works or A.E.G. reveals virtually nothing about these organizations. True reality has been side-tracked by functionalism. The objectivization of human affairs – the factory – no longer shows you the human affairs themselves. ... What is needed is, in fact, art. But the old concept of art, based on experience, is no longer valid. For whoever takes from reality only that which can be experienced through it, will never reproduce it.'[71]

Around 1930 *Neue Sachlichkeit* photography was at its height. Walker Evans (plates 87, 121, 122, 218, 269–272) remained faithful to his critically incisive style of objective reportage, while Edward Weston (plates 217, 219, 220, 236, 275) and most of the other photographers (plates 215, 262, 266, 273) almost exclusively pursued blatantly visual stimuli. The main stimuli for artistic photography since the turn of the century have been texture (plate 120) and structures seen in a rhythmical play of light and shade (plates 274–277). Even Renger-Patzsch's objective works rely far too much on formal-aesthetic motives to enable them to shed much light on the essence of what is being portrayed. The stimulus may come from the visual impact of a sequence of images (plates 161, 222); movement may be suggested by oscillations within a rhythmic group (plates 147, 166).

The photographer's attitude to what he is doing is crucial, for the result of this attitude, as in the case of the artist, is the finished work. That this attitude may occasionally be lacking in integrity is revealed in the foreword to Renger-Patzsch's book[72] where one is urged 'to seek interesting eye-sores', and where the photographs are described as being 'of the greatest possible publicity value for prospectuses and posters' ... 'There is nothing which cannot be made beautiful' ... for 'Renger's art will make it decorative.'

Characteristic of all *Neue Sachlichkeit* photography is the static moment which endows forms with a monumental quality – for we are still concerned here with form. 'The creative act lies in the choice of objects';[73] whether they are façades (plates 270, 271), pictures of people (plates 43, 196) and dummies (plates 194, 195), or a confrontation of the worlds of people and things (plates 130, 198, 199). No vestige remains of the individual – even his face becomes an ornament, albeit an impressive one (plates 133, 236, 237). Even in Cartier-Bresson's photographs – 'There is nothing in the world incapable of a decisive moment'[74] – everyday life

soon falters amidst the stage-like settings with their impressionistic overtones (plates 143, 197), which in their monumental inertia provide a perfect foil for movement (plates 143, 214): 'J'avais surtout le désir de saisir dans une seule image l'essentiel d'une scène qui surgissait.'[75]

The aim of every short exposure shot and what every photo-journalist aspires to is movement arrested at the culminating point of the action, though the movement need not necessarily be physical. It may be in mental concentration at a decisive moment (plates 101, 107). Thus, each short exposure is involved in a movement, be it only in the expression of those being photographed, waiting for the click of the shutter to free them from the rigours of their pose. With the time exposure, traces of movement are continuously forming layers one on top of another; they produce the 'human stream' (plate 102) whose flow may be read off at the few static points.

Photography as medium

Brecht once remarked on the subject of photography: 'The historical aspect of some early photographs, notably the wonderful "St Cloud, 1871", seems to have gone. I do not mean only the choice of subjects, although I also mean that, but rather that expression of uniqueness and strangeness in time which artists are able to give to their pictures – artists who understand the essence of a document. But for this one must be interested in the subject-matter – an interest in lighting is not enough. Photography should by now be past the stage where artists were preoccupied simply with demonstrating what can be done with photographic apparatus.'[76] And Kracauer said in 1928: 'It almost seems that with increasingly refined techniques the object which photography once sought to achieve is disappearing.'[77] Yet this very relationship with technique is vital for the photographer's state of awareness; for the critical area for the artist is moving almost imperceptibly towards the object whose intrinsic value is mid-way between document and work of art. In his *One-way Street*[78] Benjamin compared these terms: 'The effectiveness of a document depends on surprise. A work of art grows with repeated viewing.' But surprise wears off; all that remains is the substance, which can only survive as long as there is an inherent, central form to bind it together – in other words, as

31

long as it is art. Photography is only one medium available to the visual artist. 'Photography warrants no high esteem if it is classified as a messenger-boy for reality, or as a means of scientific research, or as a recorder of important events, or as a basis for processes of reproduction, or as "art".'[79] Its quality depends solely 'on the measure of creative intensity that its technical form' has achieved.[80]

In 1922 Tristan Tzara enthusiastically greeted photography: 'When everything calling itself art had become riddled with gout, the photographer lit his thousand-candlepower lamp and the light-sensitive paper absorbed the blackness of a few everyday objects. He had discovered the significance of a pure and delicate flash – more important by far than the glorious sight of all the constellations.'[81] And with similar emphasis, Moholy-Nagy wrote in 1927: 'This century belongs to light. Photography is the prototypical method of light-construction, if only in a transposed and – perhaps for that reason – almost abstract form.'[82]

In another connection, Moholy-Nagy has this to say: 'In the mechanically exact process of photography we possess an incomparably superior means of expression for representation than in the hitherto recorded processes of representational painting. From now on painting can concern itself with the purer, more constructive approach to colour.'[83] Picasso expressed the same sentiments in a conversation with Brassai in 1939: 'When one sees what one can express with photos, it becomes clear that some things are no longer the task of the painter. ... Why should the artist insist on portraying something that can be captured just as well by the camera? That would be stupid! Photography has come just at the right time to free painting from all literature, from the anecdote, and even from the object. ... In any case, a certain aspect of the object must belong in future in the realm of photography. ... Shouldn't painters use their newly won freedom to do something different?'[84]

Among the artist-photographers Man Ray in particular applied himself to portrait-photography. Yet the human form is for him, as it is for his contemporaries, an opportunity to show his own subjectively artistic viewpoint, for which he is always seeking a new, interesting angle. There is no submission to the aura of the individual – or what remains of it. Man Ray forces the model to adhere to his own rules of form (plates 239, 240, 242, 244–249). This concept culminates in the 'Polaroid Portraits' of Richard Hamilton (plates 250–257) taken by various well-known artist friends. Hamilton becomes a mere prop in this attempt to demonstrate that each artist's own characteristic style, like a trademark, will be evident in any medium.

When artists like Man Ray (plates 301, 302), Moholy-Nagy (plates 284, 285, 297, 298) or Hockney (plates 184, 205, 261, 263, 264) pursue objective-photography, their formal awareness, which identifies them as avant-garde, brings the image under their subjective view, which, however, has to submit to objective rules of form. This gives them an intrinsic strength. Besides this they have made some daring and imaginative experiments in technical methods and materials. From these have emerged the rayogram (plates 305–309) and the photogram (plates 303, 304) where 'light falls through objects on to light-sensitive paper by way of different coefficients of refraction; a process which can be effected with or without a camera'. Such methods lead to 'possibilities of light-construction where the light may be effectively used as a new creative tool, like colour in painting, and tone in music'.[85] And Walter Benjamin[86] acknowledged that Man Ray's photography succeeded 'in reproducing the painting techniques of the most modern painters'.

The latest technical development in photography, the hologram, is Bruce Nauman's chosen medium (plates 310, 312, 313, 316, 318). His work invites comparison with Moholy-Nagy's light-graphics; but with Nauman's hologram technique colour has really come into its own. Colour photography dates back to the early colour-cast (plate 101), and develops through to the instant colour of the polaroids (plates 254–257). The colour-photo's fascination is almost exclusively based on alienation; the divergence from natural colour opens up a whole new artificial, and hence sometimes artistic, field (plates 336, 353). All the rest is imitation. It rejects the need to convey a message in the belief that it is offering reality, transfigured by colour, whereby the infinite variety of life may be paraded more appetizingly before the consumers' eyes.

In Bruce Nauman's work, apart from the arrangement of photos into a kind of sequence, there is a further element which distinguishes it from the photograms of Man Ray or Moholy-Nagy. The photo-series is, of course, the creation, but at the same time it is the record of the process behind it – the artistic act: 'Making Faces' 1968 (plate 318). Each gesture only exists within the photo. This became the guiding principle for a whole artistic school (plates 286, 287, 314, 315, 319), for whom the documentary record is more crucial than the graphic appeal of, for instance, comparable aerial photographs (plates 320–323, 326, 327). In the case of Gilbert & George, the photo assumes this documentary role even though the formal aesthetic components are here so sophisticated that the flesh-and-blood pair, stylized into sculpture, seem to grow into a conventional, patriarchal art-form

(plates 335, 336). The photo accordingly becomes a valuable document, not least through an elegant choice of title.

For the artistic avant-garde in photography, sequence is a fundamental stylistic principle. This applies equally to the sequences of Ed Ruscha (plates 325, 328–331, 351) and Hans-Peter Feldmann (plates 333, 345), the static contrasts of Christian Boltanski (plate 339), who compiles his pictorial world in search of a childhood myth, and Bernhard and Hilla Becher (plates 343, 355), who draw their strength successfully from studies in contrasting types. Only the Bechers place much emphasis on the technical quality of the photographs used. Usually the photographic material either originates from the consumer world, or is taken specially, often not even by the artist himself, in an amateur fashion, without any artistic pretensions whatever. But the sequential arrangement which fosters coherence in the juxtaposed elements remains central to all, while the title plays an important role in imposing an interpretation upon what would otherwise appear as aesthetic informality. Accordingly Bruce Nauman satirizes Ed Ruscha's book *Various Small Fires* 1964 (plates 328–331) by burning it page by page for the series: 'Burning Small Fires' 1968 (plate 332). John Baldessari gives a detailed explanation of 'Choosing' (plate 337) which makes the process sound like the rules of a game; and Douglas Huebler makes the explanatory section a vital part of the picture series, without which it would remain a mystery.

Each sequence, even if it is static, may, by comparison, produce the effect of movement in the mind of the beholder. This can be seen in the work of William Wegman whose work has an added ingredient of humour, most impressively in 'Family Combination' 1972 (plate 341), where father, mother and son are reproduced one on top of another in the bottom row in the combination father/mother, mother/son, son/father; one is led from uncertainty into a critical awareness. The series, however, develops from the picture-pair presented for comparison (plates 357–370). Robert Smithson (plates 367, 368) included both elements of comparison in the one picture: the photo of the scene in the scene itself. Hamish Fulton's work uses intervals in time (plates 363/364) and space (plates 369, 370). The picture-pair has long been used primarily as a way of bringing movement, and in movement, time, into the visual domain (plates 346–349). And Muybridge (plates 342, 354, 356), whom the avant-garde have elevated to a kind of father-figure, had, as it were, dissected movement into a series of locomotive moments which suggest cinematographically the continuity of movement. This kinetic element was used

by Jan Dibbets in the bottle wandering about a fixed grid (plate 352). Dibbets made use of the spatial element in his panorama 'Dutch Mountains' (plate 353); the diagram records the photographic scheme by means of which the sea towers up into a mountain landscape.

However diverse the photographic material of the artistic avant-garde may be, they all have one thing in common: the conventional application of pictorial material. The exceptions are Bruce Nauman, Ed Ruscha in his 'Thirty-Four Parking Lots' (plate 325), and, most strikingly, Bernhard and Hilla Becher (plates 212, 225–227, 343, 355). In the Bechers' pictures we are presented not with a subjective view of the object, but with the object in its totality. Their uncompromising involvement with the object recalls the aims of Atget and Sander, who also eliminated the element of aura. The objects stand, as it were, naked before the lens. What an objective picture around 1930 (plate 224) demanded, but only occasionally achieved, as in the work of Karl Blossfeldt (plates 229–235), was that the object should be comprehended as an object, and that the photographer should come to terms with this, without first considering its artistic aspects: this is the point of departure for the Bechers.

Walter Benjamin's assessment of Karl Blossfeldt's work may also be applied to that of Bernhard and Hilla Becher: 'From every flower and every leaf inner visual demands leap out at us which, as metamorphoses, have the final word in all phases and stages of the witnessed object. This touches on one of the profoundest, most unfathomable forms of creativity – the hybrid, which was always nearest to the spirit and to nature, and sought after by all the creative élites. It is the fertile, dialectic antithesis to invention: the *natura non facit saltus* of the ancients. One may hazard a bold guess and call it the feminine and vegetal way of life.'[87] In the photograph alone can an unprecedented wealth of form, an unsuspected treasure of analogies be exploited. It takes the powerful enlargements of Blossfeldt and the corresponding reductions of Becher 'to cause these forms to cast off the veil which our own inertia has wrapped around them'.[88]

'A different nature speaks to the camera than speaks to the eye; different primarily in that in place of a world interwoven with human consciousness, another one, unconsciously interwoven, enters. ... One experiences this optic-unconscious with the help of the camera, just as one learns of the impulsive-unconscious through psycho-analysis. Structure, cell-tissue, with which technology and medicine strive to come to terms – all this is far more relevant to the camera than the atmospheric

landscape or the soulful portrait. But at the same time photography opens up the physiognomical aspects of pictorial worlds existing in the minutest detail, yet sufficiently clear and latent to have found refuge in waking dreams; now, grown large and definable, they demonstrate that the relationship between magic and technique is through and through a historical variable.'[89]

Thus, once photography has shaken off its initial naïveté, the work of a few artists runs through its historical development like a red thread – artists who have (in Benjamin's words) the quasi-scientific systematic awareness of Muybridge, via Atget, Sander and Blossfeldt, up to the Bechers.

Notes

At this point I would like to thank those who have helped me in my work on this book, especially Herr and Frau Fritz Gruber, Herr and Frau Gerd Sander, Ann and Jürgen Wilde. But my special thanks go to Georg Heusch who undertook the preparation of the photographic material, and also gave useful advice on the text.

In the notes book titles are given in abbreviated form; full details may be found in the bibliography.

1 Freund, p. 13
2 Benjamin, *Autor*, p. 95 and p. 115
3 Kracauer, pp. 33–4
4 Freund, p. 16
5 Matthies-Masuren, 1903 p. 12
6 H.P. Robinson, 1869
7 Benjamin, *Photographie*, p. 230
8 Benjamin, *Kunstwerk*, p. 159
9 Benjamin, *Photographie*, p. 243
10 Benjamin, *Photographie*, p. 242
11 Kracauer, p. 34
12 Benjamin, *Kunstwerk*, p. 150
13 Benjamin, *Kunstwerk*, pp. 155–6 and p. 177, n. 6
14 Benjamin, *Kunstwerk*, p. 156
15 Benjamin, *Kunstwerk*, pp. 154–5
16 Benjamin, *Kunstwerk*, p. 177, n. 5
17 Freund, pp. 107–9
18 1863; quoted in Freund, p. 94
19 Braive, p. 128
20 Scharf, 1968, p. 26
21 Scharf, 1968, p. 89; Coke, pp. 8–10
22 Delacroix, pp. 189–190
23 Delacroix, pp. 325–326
24 Benjamin, *Photographie*, p. 238
25 Matthies-Masuren's book (1903) is a unique apologia for offset printing.
26 Taine, vol. I, p. 25
27 Coke, p. 47
28 Benjamin, *Baudelaire*, p. 233
29 Freund, p. 96
30 Benjamin, *Photographie*, p. 235
31 Freund, p. 92
32 1901; quoted in Braive, p. 199
33 Coke, p. 13
34 Benjamin, *Pariser Brief*, p. 503
35 Benjamin, *Paris*, p. 190
36 Aaron Scharf, *Art and Photography*; Van Deren Coke, *The Painter and the Photograph*
37 Pollack, pp. 128–9
38 Coke, p. 84
39 Benjamin, *Photographie*, p. 231
40 Benjamin, *Photographie*, p. 232
41 Benjamin, *Kunstwerk*, p. 158
42 Benjamin, *Photographie*, pp. 233–4
43 Benjamin, *Photographie*, pp. 234–5
44 Benjamin, *Baudelaire*, p. 234
45 Adorno, *Minima Moralia*, p. 23
46 Robinson, 1869; quoted in Matthies-Masuren, p. 54
47 Benjamin, *Photographie*, p. 236
48 Benjamin, *Paris*, p. 181
49 Benjamin, *Paris*, p. 190
50 Kracauer, pp. 37–8
51 Benjamin, *Pariser Brief*, pp. 501–2
52 Benjamin, *Kunstwerk*, p. 158
53 Benjamin, *Photographie*, p. 239
54 Benjamin, *Photographie*, p. 240
55 Benjamin, *Kunstwerk*, p. 158
56 Benjamin, *Photographie*, p. 240

57 Sander, *Antlitz der Zeit*, p. 14
58 Benjamin, *Photographie*, p. 242
59 quoted in Benjamin, *Photographie*, p. 241
60 Aragon; quoted in Benjamin, *Pariser Brief*, p. 504
61 Benjamin, *Autor*, p. 112
62 Benjamin, *Kunstwerk*, p. 171
63 Benjamin, *Photographie*, p. 246
64 Benjamin, *Autor*, p. 107 and p. 110
65 Benjamin, *Pariser Brief*, p. 505
66 Benjamin, *Kunstwerk*, p. 184, n. 21
67 quoted in Benjamin, *Pariser Brief*, pp. 505–6
68 Benjamin, *Photographie*, pp. 244–5
69 Kracauer, p. 28
70 Benjamin, *Autor*, p. 106
71 1931; Brecht I, pp. 171–2
72 Renger-Patzsch, *Die Welt ist schön*, pp. 12–14
73 Brassai; quoted in Pollack, p. 366
74 Cartier-Bresson; quoted in Braive, p. 339
75 Cartier-Bresson, *Images à la Sauvette*
76 c. 1935; Brecht II, p. 74
77 Kracauer, p. 303
78 Benjamin, *Einbahnstraße*, p. 107
79 Moholy-Nagy, *Die Beispiellose Fotografie*, p.X
80 Moholy-Nagy, *Malerei Fotografie Film*, p. 8
81 quoted in Benjamin, *Photographie*, p. 244
82 Moholy-Nagy, *Die Beispiellose Fotografie*, p.XI
83 Moholy-Nagy, *Malerei Fotografie Film*, p. 7
84 Brassai, *Gespräche mit Picasso*, p. 41
85 Moholy-Nagy, *Malerei Fotografie Film*, p. 30
86 Benjamin, *Pariser Brief*, p. 505
87 Benjamin, *Neues von Blumen*, p. 153
88 Benjamin, *Neues von Blumen*, p. 152
89 Benjamin, *Photographie*, pp. 232–3

List of Artists and Plates

In the illustration list book titles are only given in abbreviated form; full details may be found in the bibliography. If no details are given, then the specimens are either taken from originals in the possession of the artist, or from monographs which may be found in the bibliography under the name of the artist.

Abbott, Berenice
born 1898 in Springfield (Ohio), lives in USA
plate 189
Jean Cocteau, c. 1930
from: *album* 7, p. 30

Adams, Ansel
born 1902 in San Francisco, lives in Carmel (California)
plate 260
Moonrise, Hernandez (New Mexico), 1941
Gruber collection, Cologne

Anon. (abbreviation for: anonymous photographer)
plate 14
F.W.J. von Schelling, c. 1850
from: Bossert/Guttmann, plate 64
plate 23
Baron A. von Budberg and his family, Berlin, 1859
from: Bossert/Guttmann, plate 118
plate 40
Prince Arthur, c. 1853
from: *From today...*, plate 8
plate 41
Inside a public house, Liverpool, c. 1895
from: Chandler, plate 32
plate 60
no title, c. 1870
from: *American Album*, p. 214
plate 74

Matilda Gibbs, c. 1858
from: Rinhart, plate 43
plate 75
Child with book, c. 1858
from: Rinhart, plate 13
plate 77
Uranie and Susanie Hutchinson (Twins), c.1850
from: *American Album*, p. 30
plate 84
Rodin and His Wife on Their Wedding Day, 29.1.1917
from: *Verve*, p. 141
plate 89
Brownstone houses, c. 1880 New York,
from: Silver, *Lost New York*
plate 91
Interior view of the Niagara suspension-bridge c. 1865
from: Recht, plate 113
plate 93
Ballards Mill, Patcham, c. 1870
from: Betjeman/Gray, plate 117
plate 97
no title, c. 1900
from: *American Album*, p. 112
plate 106
Piano *(tableau vivant)*, c. 1895
from: Braive, p. 300
plate 109
Free balloon, Paris, 1870
from: Schade, p. 19
plate 111

Mill at Düppel, 1864
from: Schade, p. 52
plate 112

A Freak of the Johnstown Flood, 1889
from: *Image of America*, p. 68
plate 113

From the Franco-Prussian War, 1870/71
Gernsheim collection, London
plate 114

St. Cloud, 1871 (The Restaurant de la Tête-Noire
following the Prussian bombardment)
from: Bossert/Guttmann, plate 182
plate 115

Berlin (after the battle of Sedan), 1870
from: Schade, p. 91
plate 116

A mound of bonfire components for a 1910 foot-
ball rally at Stanford University
from: *American Album*, p. 329
plate 125

Bedroom Interior, c. 1910
from: Szarkowski, p. 13
plate 142

Couple with Daguerreotype, c. 1850
from: Szarkowski, p. 19
plate 150

No. 67 Kings Road, Brighton, c. 1870
from: Betjeman/Gray, plate 17
plate 151

Human jigsaw by an American unit
(Photo: Weltspiegel) c. 1925
from: Moholy-Nagy, 1929, plate 37
plate 152

Poster (Continental Photo), c. 1925
from: *Querschnitt*, 5, 1925, following p. 424
plate 155

Prisoners taken by the 3rd and 4th British
Armies, between the Angre and the Somme, at
the start of the offensive which began on August
21st, 1918
Becher collection, Düsseldorf
plate 156

Bird population of the Guano island of San
Martin (Peru), c. 1925 (Wide World Photo)
from: *Querschnitt*, 12, 1926, following p. 934
plate 158

Crowd, Russia, c. 1920
from: *foto-auge*, plate 26
plate 159

2nd pilgrimage from Trier to Lourdes, Sept. 1958
Becher collection, Düsseldorf
plate 160

Blessing the colours in the Luitpoldhain, 1933
Becher collection, Düsseldorf
plate 161

Living geometry (Wide World Photo), c. 1925
from: *Querschnitt*, 12, 1926, following p. 910
plate 162

American bathing-beauty in Los Angeles, Rin-
tin-tin, Woman from the Cameroons; c. 1925
from: *Querschnitt*, 11, 1925, following p. 890
plate 202

Medical photo, c. 1925
from: *foto-auge*, plate 48
plate 216

Cat-burglar in Bologna (Wide World
Photo), c. 1925
from: *Querschnitt*, 8, 1925, following p. 720
plate 222

Twisting bobbins in production, c. 1925
from: Moholy-Nagy, 1929, plate 33
plate 224

Cooling towers (Hohensbroek, Holland; Dort-
mund). c. 1925
from: Lindner, p. 136
plate 322

Werbelin near Leipzig (Junkers' aerial photo),
c. 1928
from: *foto-auge*, plate 16
plate 323

Massow, Upper Silesia (Aero-kartographisches
Institut, Breslau), c. 1928
from: *foto-auge*, plate 17
plate 338

1700 children, photo-montage, Japan, c. 1885
from: Braive, p. 178
plate 365

A 130-year-old American from Minnesota
(Photo: Weltspiegel), c. 1925
from: Moholy-Nagy, 1929, plate 23
plate 366

A rotten apple covered in fungus (Photo:
Haus und Garten), c. 1925
from: Moholy-Nagy, 1929, plate 24

Arbus, Diane
born 1923 in New York, died 1971 in New York
plate 27

A young family in Brooklyn going for a Sunday
outing. Their baby is named Dawn. Their son is
retarded. 1966
plate 78
Identical twins, Cathleen and Colleen, members
of a twins club in New Jersey. 1966
plate 80
This is Eddie Carmel, a Jewish giant, with his
parents in the living room of their home in the
Bronx, New York. 1970
plate 82
Woman with a veil on Fifth Avenue, New York
City, 1968
plate 140
Teenage Couple, New York City, 1963
plate 206
A husband and wife in the woods at a nudist
camp, New Jersey, 1963

Atget, Eugène
born 1857 in Libourne, died 1927 in Paris
plate 34
no title, c. 1900
from: Braive, p. 293
plate 85
Paris, c. 1910
plate 92
Paris, c. 1910
Gruber collection, Cologne
plate 96
Paris, c. 1900
plate 119
Paris, c. 1910
plate 126
Paris, c. 1910
Fotogalerie Wilde, Cologne
plates 127–129
Paris, c. 1910
plate 132
Paris, c. 1910
Gruber collection, Cologne
plate 134
Paris, c. 1910
plate 259
Paris, c. 1900

Bacon, Francis
born 1909 in Dublin, lives in London
plate 256 (colour)
Richard Hamilton, 14.7.1969 (Polaroid)

Baldessari, John
born 1931 in USA, lives in Santa Monica (Cali-
fornia)
plate 337
from: Choosing, December 1971
Galerie Konrad Fischer, Düsseldorf

Barchan, P.
active around 1925
plate 138
Marc Chagall with his young daughter, c. 1925
from: Querschnitt, 11, 1926, following p. 842

Baumeister, Willi
born 1889 in Stuttgart, died 1955 in Stuttgart
plate 182
Photo-drawing, c. 1928
from: foto-auge, plate 67
plate 183
Photo-drawing, c. 1928
from: Gräff, p. 79
plate 334
Photo-montage, c. 1928
from: Gräff, p. 72

Baumgarten, Lothar
born 1944 in Rheinsberg,
lives in Düsseldorf
plates 361/362
2 photos (each 18 × 12.5 cm), 1971
Galerie Konrad Fischer, Düsseldorf

Bayard, Hippolyte
born 1801 in Breteuil-sur-Noye, died 1887 in
Nemours (France)
plate 28
Ball (the mills of Montmartre), 1839
plate 29
The roofs of Paris, 1842

Bayer, Herbert
born 1900 in Haag (Austria), lives in Aspen
(Colorado)
plate 186
Lonely city-dweller, 1932 (Photo-montage)
Gruber collection, Cologne
plate 188
Self-portrait, 1932 (Photo-montage)
Gruber collection, Cologne

from: *Time-Life Book*, p. 56
plate 290
Ruins of the Gallego Flour Mills, Richmond,
Virginia, 23.4.1865
from: Newhall, p. 70

Brandt, Bill
born 1906 in England, lives in London
plate 187
Evening in Kew Gardens, 1932
Gruber collection, Cologne

Brassai (Gyula Halasz)
born 1899 in Brasso (Hungary), lives in Paris
plate 43
Two Apaches, Paris, 1932
Gruber collection, Cologne
plate 191
Picasso, Wooden head on top of a radiator, 1943
from: Kahnweiler/Brassai, plate 188
plate 198
Shop window, 1937
plate 199
Something to look at, 1935
plate 267
Balearic Islands, 1953
Gruber collection, Cologne

Callahan, Harry
born 1912 in Detroit, lives in Rhode Island (USA)
plate 291
Midwest, c. 1949
plate 300
Chicago, 1949

Cameron, Julia Margaret
born 1815, lived in London, died 1879
plate 81
Sir John Herschel, 1867
from: Brevern, plate 3

Capa, Robert
born 1913 in Budapest, died 1954
in Indo-China
plate 110
Germany, 1945
from: *The concerned photographer*

Carjat, Etienne
born 1828, lived in Paris, died 1906
plate 16

Charles Baudelaire, c. 1862
from: *Verve*, p. 147

Carroll, Lewis (Charles Lutwidge Dodgson)
born 1832, lived in Oxford, died 1898
plate 2
Julia and Adeline Jackson, c. 1870
from: *From today...*, plate 14
plate 61
Xie Kitchin – a child friend, c. 1873
from: *From today...*
plate 62
Grace Denman, Little Dear, 1864
plate 63
Alice Margaret Harington, c. 1865
plate 64
Irene MacDonald, It won't come smooth, 1863
plate 66
Maria White, 1864

Cartier-Bresson, Henri
born 1908, lives in Paris
plate 130
Mexico, 1934
Neue Sammlung, Munich
plate 133
New York, 1947
plate 143
Sevilla, 1933
Gruber collection, Cologne
plates 157, 197
Moscow, 1954
plate 214
Madrid, 1933
Gruber collection, Cologne
plate 237
Mexico, 1934

Coburn, Alvin Langdon
born 1882 in Boston, died 1966 in Wales
plate 258
Ezra Pound, 1916
plate 283
The Octopus, New York, 1912
Gruber collection, Cologne

Coppola, Horacio
active in Buenos Aires around 1930
plate 344
from: *Cahiers d'Art*, 1934, p. 73

Cuvelier, Adalbert
active in France around 1850
plate 32
Region of Arras, 1852
from: Scharf, 1968, plate 58

Daguerre, Louis Jacques Mandé
born 1787 in Cormeilles-en-Parisis, died 1851 in Paris
plate 30
Boulevard in Paris, 1839
Bayerisches Nationalmuseum, Munich

Degas, Edgar
born 1834 in Paris, died 1917 in Paris
plate 8
Self-portrait with Zoe, c. 1895
from: Newhall, p. 93
plate 13
Renoir and Mallarmé, c. 1893
from: Braive, p. 200

Delamotte, Philip Henry
born 1820, lived in London, died 1889
plate 208
Crystal Palace: the open colonnade, garden front, 1853
from: *From today...*, plate 30
plate 209
Crystal Palace: the upper gallery, 1853
from: *From today...*, plate 31
plate 213
Crystal Palace, London, 1854
from: Schade, p. 26

Dibbets, Jan
born 1941 in Weert (Holland), lives in Amsterdam
plate 352
Painting Film Black Vase Horizontal, 1972
(92 × 89 cm)
Galerie Konrad Fischer, Düsseldorf
plate 353 (colour)
Panorama (Dutch Mountains), 1971
(70 × 70 cm; 11 photos)
Galerie Konrad Fischer, Düsseldorf

Dine, Jim
born 1935 in Cincinnati (Ohio), lives in London

plate 251
Richard Hamilton, 27.12.1968 (Polaroid)

Eakins, Thomas
born 1844, lived in Philadelphia, died 1916
plates 50, 51
no title, 1884
Philadelphia Museum of Art
plate 52
Double jump, 1885
from: Newhall, p. 87
plate 55
Wrestlers, c. 1889 (8.9 × 14.6 cm)
Joseph Hirshhorn collection, New York
plate 71
Two of the artist's nephews at the farm in Avondale, c. 1888 (8.9 × 10.7 cm)
Gordon Hendricks collection, New York
plate 265
Sailboats, Delaware River, c. 1885
(7.9 × 12.4 cm)
Philadelphia Museum of Art

Erfurth, Hugo
born 1874 in Halle, died 1948 in Gaienhofen/Bodensee
plate 243
Oskar Schlemmer, c. 1925

Ernst, Max
born 1891 in Brühl/Cologne, lives in Seillans (Var), France
plate 118
Massacre of the Innocents, 1920/21 (photo-montage with water colours and pastels; 21 × 29.2 cm)
Simone Collinet collection, Paris
plate 238
for Gala, c. 1920 (photo-painting)
from: *foto-auge*, plate 43

Erwitt, Elliot
born 1928 in Paris, lives in Los Angeles
plate 103
Ballycotton, Ireland, 1968
plate 105
Pasadena, California, 1963
plate 164
Las Palmas, 1964

44

Evans, Frederick H.
born 1853, lived in London, died 1943
plate 274
The Sea of Steps – Wells Cathedral, England,
1903
from: Newhall, p. 110

Evans, Walker
born 1903 in St.Louis (Missouri), lives in Yale
plate 87
222 Columbia Heights, Brooklyn (North Dako-
ta), c. 1931
plate 121
The Home Organ, Chester (Nova Scotia), 1968
plate 122
Bedroom, Shrimp Fisherman's House, Biloxi
(Mississippi), 1945
plate 218
Gas Station, Reedsville (West Virginia), 1936
plate 269
Corrugated Tin Façade, 1936
plate 270
Doorway, Nyack (New York), c. 1931
plate 271
Maine Pump, 1933
from: Newhall, p. 145
plate 272
Breakfast Room at Belle Grove Plantation,
White Chapel (Louisiana), 1935

Feldmann, Hans-Peter
born 1941 in Düsseldorf, lives in Düsseldorf
plate 333
from: "6 Bilder von Feldmann", 1971
plate 345
from: "11 Bilder von Feldmann", 1969

Fiorenza, Vito
active in Sicily around 1950
plate 24
no title, c. 1950
from: The Family of Man, p. 56

Frank, Robert Louis
born 1924 in Switzerland, lives in New York
plate 294
Paris, 1949/50

Friedlander, Lee Norman
born 1934 in Aberdeen (Washington), lives in

New City (New York)
plate 193
from: Work from the same house, c. 1968
plate 292
Self-portrait, Minnesota, 1966
plate 299
Montana, 1970
Museum of Modern Art, New York

Frith, Francis
born 1822, lived in London, died 1898
plate 37
Rameses the Great, Abu Simbel, c. 1856
from: From today..., plate 33

Froissard
active in Lyons around 1855
plate 36
The floods in Lyons, 1856
from: Braive, p. 225

Fulton, Hamish
born 1946 in London, lives in Canterbury
plates 363, 364
Marley Wood Lane, Kent, 1971
plates 369/370
from: Hollow Lane, 1971

Garnett, William
active in Los Angeles around 1950
plates 326, 327
Housing Developments, c. 1950
from: Adams/Newhall, p. 59

Gibson, Ralph
born 1939 in Los Angeles, lives in New York
plates 295, 296
from: The Somnambulist, 1970
Fotogalerie Wilde, Cologne

Gilbert & George
live in London
plate 252
with Richard Hamilton, 12.11.1970 (Polaroid)
plate 335
8 Part Photo – Piece, Christmas 1971 (8 photos,
each 25 × 20 cm)
Galerie Konrad Fischer, Düsseldorf
plate 336 (colour)

Morning Light for Art for All, Photosculpture, 1972 (40 × 33 cm)
Galerie Konrad Fischer, Düsseldorf

Hamilton, Richard
born 1922 in London, lives in London
plate 250
Self-portrait, 3.1.1972

Heartfield, John (Helmut Herzfelde)
born 1891 in Berlin, died 1968 in Berlin
plate 149
Subjects, 1929 (Photo-montage)
plate 153
To the Depression-Party Conference of the S.P.D., 15.6.1931 (Photo-montage)
plate 154
I am a cabbage-head ..., February 1930 (Photo-montage)

Heizer, Michael
born 1944 in Berkeley (California), lives in New York
plate 287
Abstraction of dissipate, 1968
from: *When Attitudes...*

Hermanos, Courret
active in Lima around 1865
plate 39
no title, Lima, c. 1868
from: Braive, p. 101

Hill, David Octavius
born 1802 in Perth, worked together with Robert Adamson (1821–1848), died 1870 in Newington Lodge (Scotland)
plate 3
The Grierson sisters, c. 1845
plate 4
The McCandlish children, c. 1845
from: Newhall, p. 41
plate 7
Miss Rigby, c. 1845
plate 10
John Henning and Alexander Handiside Ritchie, c. 1845
Gruber collection, Cologne
plate 11

Reverend Thomas Henshaw Jones, c. 1845
plate 12
Thomas Duncan and his brother, c. 1845
from: Newhall, p. 38
plate 42
Newhaven fishermen, c. 1845
from: *From today...*, plate 1
plate 59
Newhaven Fishwife, c. 1845

Hockney, David
born 1937 in Bradford, lives in London and Los Angeles
plate 184
Diving Man, c. 1965
plate 205
Peter, c. 1965
plate 254 (colour)
Richard Hamilton, 28.1.1970 (Polaroid)
plate 261
Landscape, c. 1965
plate 263
Cadillac, c. 1965
plate 264
Clouds, c. 1965

Huebler, Douglas
born 1924 in Ann Arbor (Michigan), lives in Bradford (Massachusetts)
plate 350
Duration Piece No.14, May 1970

Huené, Hoyningen
born 1900 in Russia, died 1968 in Los Angeles
plate 173
Comrades, c. 1930
plate 185
On the diving-board, c. 1930

Ines, Antonio de
active in Palencia (Spain)
plate 79
Family portrait, Palencia, 1870
D. Gerardo Vielba, collection

Johnston, Frances B.
born 1864 in Grafton (West Virginia), died 1952 in New Orleans
plate 47

46

Stairway of Treasurer's Residence. Students at Work, 1899

Kertész, André
born 1894 in Budapest, lives in New York
plate 123
Magda, Paris, 1926
from: *The concerned photographer*
plate 124
Chez Mondrian, Paris, 1926
Gruber collection, Cologne
plate 281
West 23rd Street, 1970
from: *Time-Life Book*, p. 163
plate 324
Brick Walls, 1961
from: Szarkowski, p. 90

Koenigswald, R. v.
active in Munich around 1930
plate 102
Human stream, 1930
Fotogalerie Wilde, Cologne

Krims, Leslie
born 1943 in Brooklyn (New York), lives in Buffalo (New York)
plate 200
Mom's Snaps, 1970
Fotogalerie Wilde, Cologne
plate 201
Dentist's Fiction, 1970
Fotogalerie Wilde, Cologne
plates 203, 204
from: *The Little People of America*, 1971
Fotogalerie Wilde, Cologne

Lartigue, Jacques Henri
born 1896, lives in Paris
plate 56
The Race Course at Auteuil, Paris, 1910
Fotogalerie Wilde, Cologne
plate 57
At the Races, Nizza, 1910
Fotogalerie Wilde, Cologne
plate 58
Bois de Boulogne, c. 1910
Fotogalerie Wilde, Cologne
plate 76

Simone Roussel on Beach at Villerville, 1906
Gruber collection, Cologne
plate 98
Bichonnade, 1905
Gruber collection, Cologne
plate 99
Flight on 3.4.1904
Gruber collection, Cologne
plate 101 (colour)
Fishing party at the Château de Rouzat in Auvergne, 1913
from: *Zoom*, p. 43
plate 104
Mary Lancret, Avenue des Acacias, Paris, 1912
Gruber collection, Cologne

Le Bas
active in Japan around 1865
plate 21
Captain and soldiers from Simonosaki, 1864
from: Braive, p. 83

Lee, Russell
born 1903 in USA, lives in USA
plate 215
Kitchen of Tenant Purchase Client, Hidalgo (Texas), 1939
from: Szarkowski, p. 33

Leen, Nina
born in Russia, living since 1945 in USA
plate 25
Four Generations of an Ozark Farming Family, 1948
from: *The Family of Man*, p. 59

LeGray, Gustave
born 1820, lived in Paris, died 1862 in Egypt
plate 33
Fontainebleau Wood, 1856
from: Braive, p. 133

Lissitzky, El
born 1890 in Polschinok (Smolensk), died 1941 in Moscow
plate 241
Composition, 1924
Fotogalerie Wilde, Cologne

Lyon, Danny
born 1942 in USA, lives in USA
plate 147
Wisconsin, 1962
from: Szarkowski, p. 125
plate 166
Cotton pickers, c. 1970

Maria, Walter de
born 1935 in Albany (California), lives in New York
plate 286
Nevada, USA: Two parallel lines – 12 feet apart – in chalk – running for a full mile, 1968
from: *When Attitudes...*

Michals, Duane
born 1932 in Mokeesport (Pennsylvania), lives in New York
plate 207
Paradise Regained, 1968
Fotogalerie Wilde, Cologne

Moholy-Nagy, László
born 1895 in Borsod (Hungary), died 1946 in Chicago
plate 278
no title, c. 1926
plate 284
View from the Radio Tower, Berlin, 1928
from: Gernsheim, plate 169
plate 285
On the beach, c. 1930
from: Brevern, plate 38
plates 297, 298
Positive–Negative, c. 1925
plates 303, 304
Photogram, c. 1923
Dr. Franz Roh collection, Munich

Morris, Wright
born 1910 in Central City (Nebraska), lives in USA
plate 273
no title, 1942
from: *camera*, 4, 1966, p. 17

Muybridge, Eadweard
born 1830 in Kingston-on-Thames, lived from

1852 in America, died 1904 in Kingston-on-Thames
plate 49
Kangaroo jumping, c. 1885
plate 54
Wrestlers, c. 1885
plate 146
Gull flying, c. 1885
plate 342
Paralytic child walking on all-fours, c. 1885
plate 354
Goat walking, pulling sulky, c. 1885 (Detail)
plate 356
Horse in various actions, c. 1885 (Detail)

Nadar (Gaspard Félix Tournachon)
born 1820 in Paris, died 1910
plate 6
Maria Fauquet, 1856
from: Braive, p. 120
plate 9
Eugène Delacroix, 1861
Gruber collection, Cologne
plate 22
Proudhon, 1853
from: Braive, p. 127
plate 86
Sewers of Paris, c. 1860
from: Bossert/Guttmann, plate 185

Nauman, Bruce
born 1941 in Fort Wayne (Indiana), lives in San Francisco
plate 310
William T. Wiley or Ray Johnson Trap, 1967
(170.1 × 101.6 cm)
Cy Twombly collection, Rome
plate 311 (colour)
Cold Coffee Thrown Away, 1966
Whitney Museum, New York
plates 312, 313
Light Trap for Henry Moore, No. 1; No. 2; 1967
Galleria Sperone, Turin
plate 316
from: *Second Hologram Series,* 1969
Leo Castelli Gallery, New York
plate 318
from: *First Hologram Series (Making Faces),* 1968
Leo Castelli Gallery, New York

plate 332
Burning Small Fires, 1968
Galerie Konrad Fischer, Düsseldorf

Nègre, Charles
born 1820 in Grasse (France), lived in Paris, died
1880
plate 45
The Imperial Asylum at Vincennes, The Linen
Room, 1860
plate 46
The Imperial Asylum at Vincennes, The Kit-
chens, 1860
plate 48
The Imperial Asylum at Vincennes, The Dispen-
sary, 1860

Newman, Arnold
born 1918, lives in USA
plate 288
Martha Graham, 1961
from: *Life Library*, p. 113

Oldenburg, Claes
born 1929 in Stockholm, lives in New York
plate 253
Richard Hamilton, 12.7.1969 (Polaroid)

Oppenheim, Dennis
born 1938 in Mason City (Washington), lives in
Brooklyn (USA)
plate 319
Vector Spear, June 1968 – Oats Field near Ham-
burg
from: *When Attitudes...*

Petschow, Robert
plate 320
Cornfield, c. 1926
from: *Das Deutsche Lichtbild*, 1927, plate 121

Primoli, Giuseppe
born 1851, lived in Paris and Rome, died 1927
plate 117
Figurine vendor outside the church of St Agnese
in the Piazza Navona, Rome, c. 1890
plate 120
Bedroom in Primoli's house, Rome, c. 1895

Ray, Man
born 1890 in Philadelphia, living since 1921 in
Paris
plate 239
Dora Maar, 1936
plate 240
Sleeping Model, 1931 (Solarization)
Gruber collection, Cologne
plate 242
Salvador Dali, 1936
Gruber collection, Cologne
plate 244
Violon d'Ingres, 1924
Gruber collection, Cologne
plate 245
La Toilette (Kiki), 1928
plate 246
Yves Tanguy, 1936
plate 247
Anna de Noailles, c. 1930
Gruber collection, Cologne
plate 248
Jean Cocteau, 1925
Gruber collection, Cologne
plate 249
Sinclair Lewis, c. 1930
plate 257 (colour)
Richard Hamilton, 27.10.1971 (Polaroid)
plate 301
Object (Man), 1918
plate 302
no title, c. 1920
plates 305, 306, 309
Rayogram, c. 1925
Gruber collection, Cologne
plate 307
Rayogram, 1924
Gruber collection, Cologne
plate 308
Rayogram, 1926
Gruber collection, Cologne

Regnault, Henri Victor
born 1810, lived in Paris, died 1878
plate 31
Study at Sèvres, c. 1852
from: *From today...*, plate 25

Rejlander, Oscar Gustave
born 1813 in Sweden, lived in London, died 1875

49

plate 90
Hard times, 1860
from: Pollack, p. 153

Renger-Patzsch, Albert
born 1897 in Würzburg, died 1966 in Wamel/
Möhnesee
plate 131
Showroom at the Fagus works, c. 1925
Fotogalerie Wilde, Cologne
plate 163
Irons used in shoemaking, Fagus works, c. 1925
Fotogalerie Wilde, Cologne
plate 210
Cable railway guide-rail, Mathildenhöhe near
Bad Harzburg, c. 1925
Fotogalerie Wilde, Cologne
plate 221
Bobbins, c. 1925
Fotogalerie Wilde, Cologne
plate 223
Shoemaker's lasts, c. 1925
Fotogalerie Wilde, Cologne
plate 282
Quern, Halligen, c. 1925
Fotogalerie Wilde, Cologne
plate 289
Eichenkamp in Wamel, c. 1958
Gruber collection, Cologne

Riis, Jacob A.
born 1849 in Ribe (Denmark), lived from 1869 in
USA, died 1914 in Barre (USA)
plate 44
Mulberry Bend, New York, 1888
Gernsheim collection, London

Rinke, Klaus
born 1939 in Wattenscheid/Ruhr, lives in Düssel-
dorf
plate 314
Flow (sequence of moments), Galleria L'Attico,
Rome, 1972
plate 315
from: *Mutation (Gesten des Oberkörpers)*, 1970

Rossetti, Dante Gabriel
born 1828 in London, died 1882 in Birchington-
on-Sea

plate 68
Jane Morris, July 1865
from: Gernsheim, plate 71

Rot, Dieter
born 1930 in Hanover, lives in Düsseldorf
plate 255 (colour)
Richard Hamilton, 23.12.1968 (Polaroid)

Ruscha, Edward
born 1937 in Omaha (Nebraska), lives in Los
Angeles
plate 325
from: *Thirty-Four Parking Lots*, 1967
from: *camera*, 6, 1972, p. 40
plates 328–331
from: *Various Small Fires*, 1964
plate 351
from: *Twenty-Six Gasoline Stations*, 1962
from: *camera*, 6, 1972 pp. 36/7

Salomon, Erich
born 1886 in Berlin, died 1944 in Auschwitz
plate 107
Geneva, League of Nations, public gallery, c.
1930
Gruber collection, Cologne
plate 108
Paris, 1931
Gruber collection, Cologne
plates 348/349
Second Hague Conference, 11 o'clock in the
morning; 1 o'clock at night, 1930
Gruber collection, Cologne

Sander, August
born 1876 in Herdorf/Sieg, died 1964 in Cologne
plate 1
Girl (in circus caravan), Düren, 1932
Fotogalerie Wilde, Cologne
plate 5
Country girls, 1927
Fotogalerie Wilde, Cologne
plate 83
The country gentleman, 1923
Fotogalerie Wilde, Cologne
plate 137
The painter, Cologne, 1927
Fotogalerie Wilde, Cologne

50

The Family, Luzzara (Italy), 1953
plate 268
Church, Vermont (New England), 1944
plate 279
Abstraction, Porch Shadows, Connecticut, 1915
plate 280
The court, New York, 1924

Talbot, William Henry Fox
born 1800, lived in Lacock Abbey, Wiltshire,
died 1877
plate 35
The Haystack, c. 1845
plate 94
Miss Horatia Fielding, c. 1842

Turner, Benjamin Bracknell
born 1830, lived in London, died 1894
plate 95
Crystal Palace, London, c. 1852
from: *Un siècle...*, plate 7

Vink, John
born 1948 in Brussels, lives in Brussels
plate 293
no title, 1972
Fotogalerie Wilde, Cologne

Wegman, William
born 1943 in Holyoke (Massachusetts), lives in
Santa Monica (California)
plate 341
Family Combination, 1972 (6 Photos)
Galerie Konrad Fischer, Düsseldorf
plates 357/358
Differences, Dec. 1970 (2 Photos)
plates 359/360
no title, 1971 (2 Photos)
Galerie Konrad Fischer, Düsseldorf

Weston, Brett Theodore
born 1911 in Los Angeles, lives in Carmel (Cali-
fornia)
plate 266
Roofs of corrugated iron, c. 1925
from: *foto-auge*, plate 34

Weston, Edward
born 1886 in Highland Park (Illinois), died 1958
in Wildcuthill (California)

plate 217
Mammy – U.S.61 (Mississippi), 1941
from: *Time-Life Book*, p. 174
plate 219
no title, 1937
Gruber collection, Cologne
plate 220
Hot Coffee, Mojave Desert, 1937
from: Szarkowski, p. 16
plate 236
Rose Covarrubias, 1926
plate 275
Church Door, Hornitos, 1940
Gruber collection, Cologne

Willinger, M.
active in Berlin 1930
plate 211
Radio tower painter, 1936
from: *Das Deutsche Lichtbild*, 1937, p. 9

White, Clarence H.
born 1871 in Ohio, lived in New York, died 1925
in Mexico
plate 69
Spring 1898
Museum of Modern Art, New York
plate 70
On the way to school, 1908
plate 73
Miss Grace, 1898
from: *camera*, 11, 1972, p. 26

Zille, Heinrich
born 1858 in Radeburg, died 1929 in Berlin
plate 136
Coffins for the poor, c. 1910
plates 346/347
Hand-stand in the suburban sand-pit, c. 1910

Zola, Emile
born 1840 in Paris, died 1902 in Paris
plate 67
Mademoiselle Leblond Zola, c. 1900
from: Braive, p. 295

Bibliography

Adams/Newhall, *This is the American Earth* New York, 1960

Adorno, Theodor W., *Minima Moralia*, Frankfurt, 1951

Album 7, London, 1970

Album 12, London, 1970

American Album, New York, 1968

Arbus, Diane, *New York*, 1972

Ars Povera (Germano Celant), Tübingen, 1969; as *Art Povera* London and New York, 1969

Atget, Eugène, *Lichtbilder*, (Camille Recht), Paris/Leipzig, 1931

Atget, Eugène, *A vision of Paris*, New York, 1963

Bayard, (Lo Duca), Paris, 1943

Bellmer, Hans, *Die Puppe*, Berlin, 1962

Bellocq, E. J., *Storyville Portraits*, New York, 1970

Benjamin, Walter, *Das Kunstwerk im Zeitalter seiner technischen Reproduzierbarkeit*, 1936; in: *Illuminationen*, Frankfurt, 1961; *Illuminations: Essays and Reflections*, ed. Arendt, Hannah, Cape

Benjamin, Walter, *Paris, die Hauptstadt des XIX. Jahrhunderts;* in: *Illuminationen*, Frankfurt, 1961; *Illuminations: Essays and Reflections*, ed. Arendt, Hannah, Cape

Benjamin, Walter, *Über einige Motive bei Baudelaire;* in: *Illuminationen*, Frankfurt, 1961; *Illuminations: Essays and Reflections*, ed. Arendt, Hannah, Cape

Benjamin, Walter, *Kleine Geschichte der Photographie*, 1931; in: *Angelus Novus*, Frankfurt, 1966

Benjamin, Walter, *Der Autor als Produzent*, 1934; in: *Versuche über Brecht*, Frankfurt, 1966

Benjamin, Walter, *Neues von Blumen*, 1928; in: *Gesammelte Schriften*, Vol. III, Frankfurt, 1972

Benjamin, Walter, *Pariser Brief* (2), 1936; in: *Gesammelte Schriften*, Vol. III, Frankfurt, 1972

Benjamin, Walter, *Einbahnstraße;* in: *Gesammelte Schriften*, Vol. IV, Frankfurt, 1972

Betjeman/Gray, *Victorian and Edwardian Brighton from old photographs*, London, 1972

Blossfeldt, Karl, *Wundergarten der Natur*, Berlin, 1932

Bossert/Guttmann, *Aus der Frühzeit der Photographie 1840–70*, Frankfurt, 1930

Braive, Michel F., *Das Zeitalter der Photographie*, Munich, 1965

Brassai, *Camera in Paris*, London/New York, 1949

Brassai, *Gespräche mit Picasso*, Hamburg, 1966

Brecht, Bertold, *Schriften zur Literatur und Kunst*, Vol. I and II, Frankfurt, 1967

Brevern, Marilies v., *Künstlerische Photographie*, Berlin, 1971

Cahiers d'Art, Paris, 1934

Harry Callahan, New York, 1967

Camera, 4, Lucerne, 1966

Camera, 12, Lucerne, 1968

Camera, 6, Lucerne, 1972

Camera, 11, Lucerne, 1972

Lewis Carroll, Photographer, (Helmut Gernsheim), London, 1949

Cartier-Bresson, Henri, *Images à la Sauvette*, Paris, 1952

Cartier-Bresson, Henri, *Menschen in Moskau*, Düsseldorf, 1955

Chandler, George, *Victorian and Edwardian Liverpool and the North West from old photographs*, London, 1972

Alvin Langdon Coburn, Photographer, (H. and A. Gernsheim), London, 1966

Coke, van Deren, *The painter and the photograph from Delacroix to Warhol*, Albuquerque, 1972

Das Deutsche Lichtbild, Berlin, 1927

Das Deutsche Lichtbild, Jahresschau 1937, Berlin, 1936

Delacroix, Eugène, *Les plus belles lettres*, Paris

Eakins, Thomas, *His Photographic Works*, Pennsylvania, 1969

The photographs of Thomas Eakins, (Gordon Hendricks), New York, 1972

Erfurth, Hugo, *Bildnisse*, Gütersloh, 1961

Erwitt, Elliot, *Photographs and Anti-Photographs*, New York, 1972

Walker Evans, New York, 1971

Flash art, 35–36, Milan, 1972

Foto-auge, (Franz Roh and Jan Tschichold), Stuttgart, 1929

Frank, Robert, *The lines of my hand*, New York, 1972

Freund, Gisèle, *Photographie und bürgerliche Gesellschaft*, Munich, 1968

Friedlander, Lee,/Dine, Jim, *Work from the same house*, London, 1969

Friedlander, Lee, *Self Portrait*, New York, 1970

From today painting is dead, The Beginnings of Photography, London, 1972

Fulton, Hamish, *Hollow Lane*, London, 1972

Gernsheim, Helmut, *Creative Photography*, London, 1962

Gräff, Werner, *Es kommt der Neue Fotograf*, Berlin, 1929

Hamilton, Richard, *Polaroid Portraits*, London, 1972

Heartfield, John, *Leben und Werk*, (Wieland Herzfelde), Dresden, 1962

David Octavius Hill, (Heinrich Schwarz), Leipzig, 1931

David Octavius Hill, (Heinrich L. Nickel), Halle/Saale, 1960

David Hockney; in: *creative camera*, 80, London, 1971

Huebler, Douglas, Münster, 1972

Hoyningen Huené, *Meisterbildnisse*, Berlin, 1932

Hundert Jahre Photographie 1839–1939 aus der Sammlung Gernsheim, London, Cologne, 1959

Image of America, Early Photography 1839 to 1900, Washington, 1957

ohnston, Frances B., *The Hampton Album*, New York, 1966

Kahnweiler/Brassai, *Les Sculptures de Picasso*, Paris, 1949

Kracauer, Siegfried, *Die Photographie*, 1927; in: *Das Ornament der Masse*, Frankfurt, 1963

Life Library of Photography, *The Great Themes*, New York, 1970

Lindner, Werner, *Bauten der Technik*, Berlin, 1927

Lyon, Danny, *Conversation with the Dead*, New York/Chicago/San Francisco, 1969/70/71

Matthies-Masuren, F., *Die Bildmäßige Photographie*, Halle, 1903

Moholy-Nagy, *Malerei Fotografie Film*, Munich, 1927

Moholy-Nagy, *Die Beispiellose Fotografie;* in: *Das Deutsche Lichtbild*, Berlin, 1927

Moholy-Nagy, *Von Material zur Architektur*, Munich, 1929

Moholy-Nagy, *60 Fotos*, (Franz Roh), Berlin, 1930

Eadweard Muybridge, Animals in motion, (Lewis S. Brown), London/New York, 1957

Nauman, Bruce, *Work from 1965 to 1972*, Los Angeles, 1972

Nègre, Charles, in: *French Primitive Photography*, New York, 1970

Newhall, Beaumont, *The history of photography from 1839 to the present day*, New York, 1964

Pollack, Peter, *Die Welt der Photographie*, Vienna/Düsseldorf, 1962

Il Conte Primoli, Un Fotografo Fin de Siècle, (Lamberto Vitali), Turin, 1968

Der Querschnitt, 5 and 8, Berlin, 1925

Der Querschnitt, 11 and 12, Berlin, 1926

Man Ray, Photographies 1920–1934, Paris/New York, 1934

Man Ray, Portraits, (L. Fritz Gruber), Gütersloh, 1963

Man Ray, (Giulio Carlo Argan), Turin, 1970

Recht, Camille, *Die Alte Photographie*, Paris/Leipzig, 1931

Renger-Patzsch, Albert, *Die Welt ist schön*, Munich, 1928

Rinhart, *American Daguerreian Art*, New York, 1967

Ruscha, Edward, *Various Small Fires*, Los Angeles, 1964

Salomon, Erich, *Berühmte Zeitgenossen in unbewachten Augenblicken*, Stuttgart, 1931

Sander, August, *Antlitz der Zeit*, Munich, 1929

Schade, Wolfgang, *Europäische Dokumente, Historische Photos aus den Jahren 1840–1900*, Stuttgart/Berlin/Leipzig

Scharf, Aaron, *Creative Photography*, London, 1965

Scharf, Aaron, *Art and Photography*, London, 1968

Silver, Nathan, *Lost New York*, New York, 1971

Steichen, Edward, *Ein Leben für die Fotografie*, Vienna/Düsseldorf 1965

Steinberg, Saul; in: *Creative camera*, 56, London, 1969

Stelzer, Otto, *Kunst und Photographie*, Munich, 1966

Alfred Stieglitz, Washington, 1958

Strand, Paul, *A Retrospective Monograph*, Vol. I *The Years 1915–1946*, Vol. II, *The Years 1950–1968*, USA, 1971

Szarkowski, John, *The Photographer's Eye*, New York, 1966

Taine, Hippolyte, *Philosophie der Kunst* (1865–1869), 2 Vols., Leipzig, 1902

Talbot, William Fox, *The pencil of nature*, (Beaumont Newhall), New York, 1968

54

William H. Fox Talbot, (André Jammes), Lucerne, Frankfurt, 1972

The concerned photographer, New York, 1968

The Family of Man, New York, 1955

Time-Life Book, *Great Photographers*, New York, 1971

Un siècle de photographie de Niepce à Man Ray, Paris, 1965

Verve, Nos. 5–6, Paris, 1939

Weimar, Wilhelm, *Die Daguerreotypie in Hamburg 1839–1860*, Hamburg, 1915

The Daybooks of Edward Weston, (Nancy Newhall), New York

When Attitudes Become Form, Bern, 1969

Clarence H. White; in: *du*, June 1971, Zürich, 1971

Zille, Heinrich, *Mein Photo-Milljöh*, (Friedrich Luft), Hannover, 1967

Zoom, 11, Paris, 1972

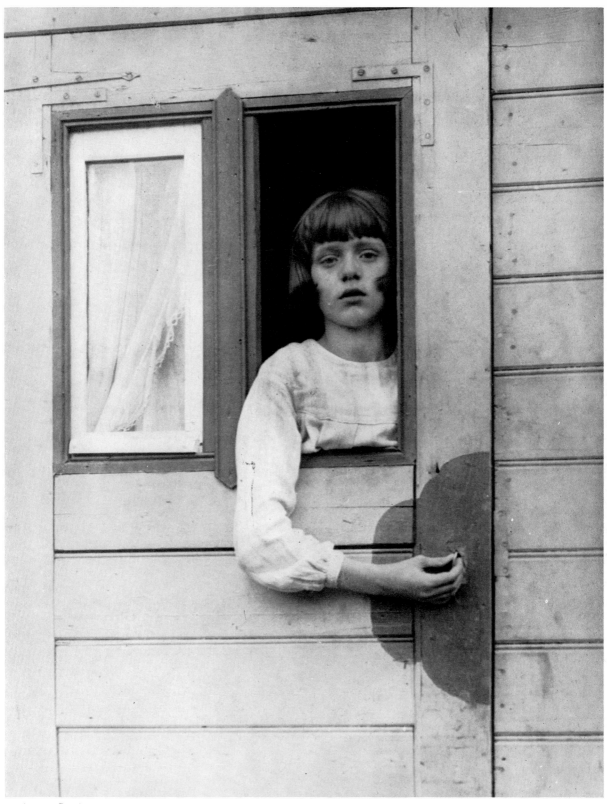

1 August Sander, c. 1930

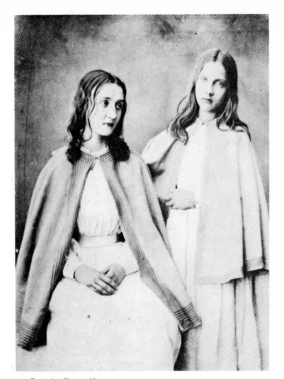

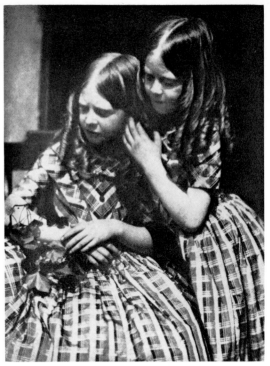

2 Lewis Carroll, c. 1870 3 D. O. Hill, c. 1845

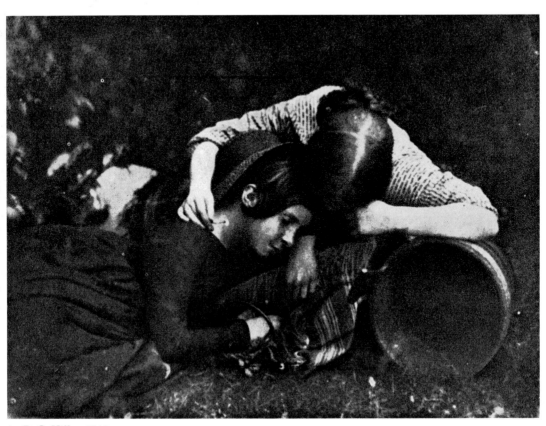

4 D. O. Hill, c. 1845

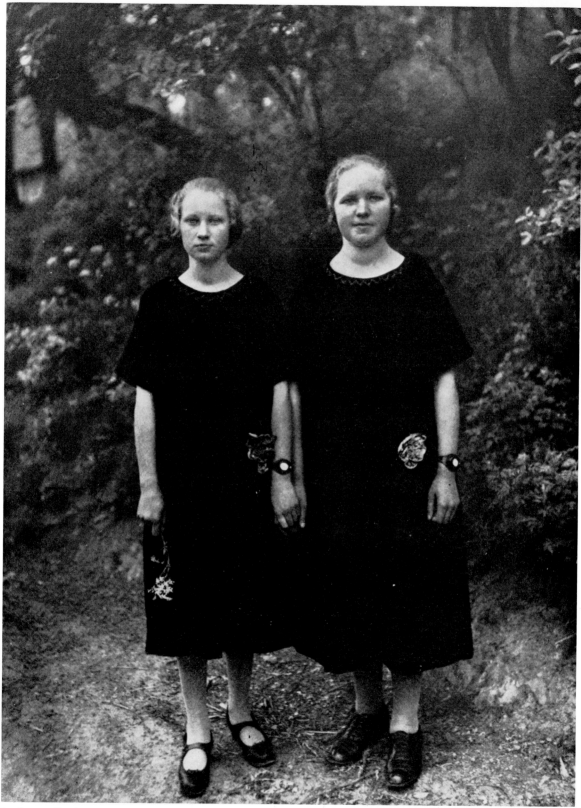

5 August Sander, 1927

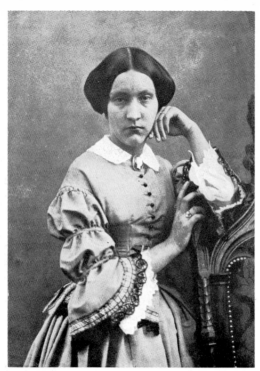

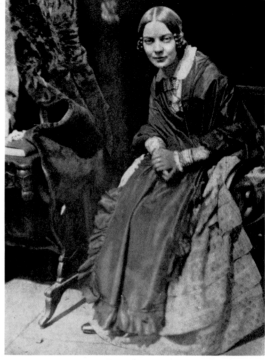

6 Nadar, 1856

7 D. O. Hill, c. 1845

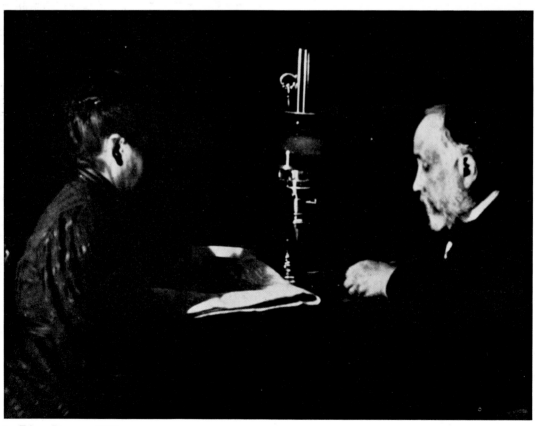

8 Edgar Degas, c. 1895

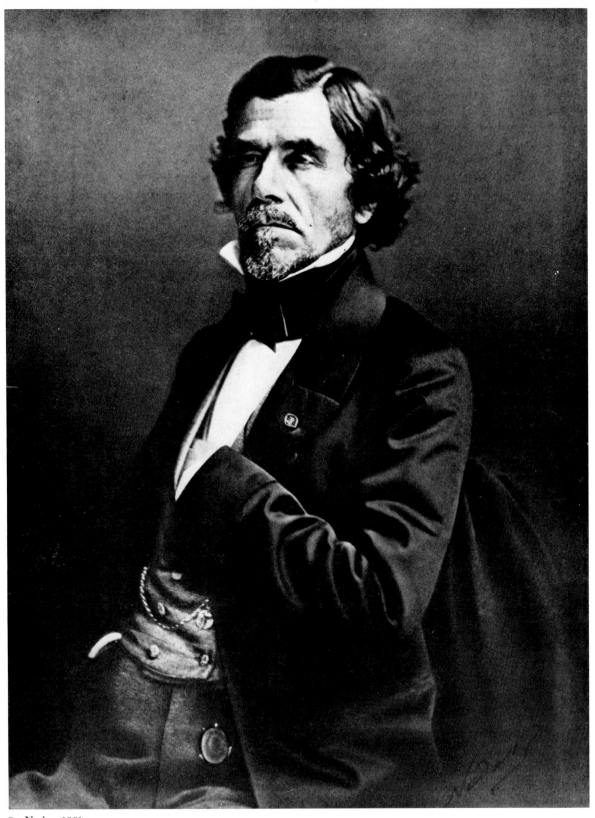

9 Nadar, 1861

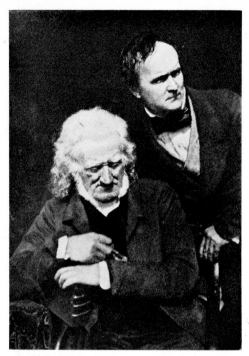

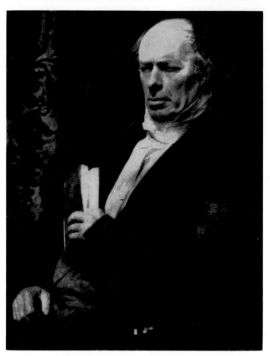

10 D. O. Hill, c. 1845

11 D. O. Hill, c. 1845

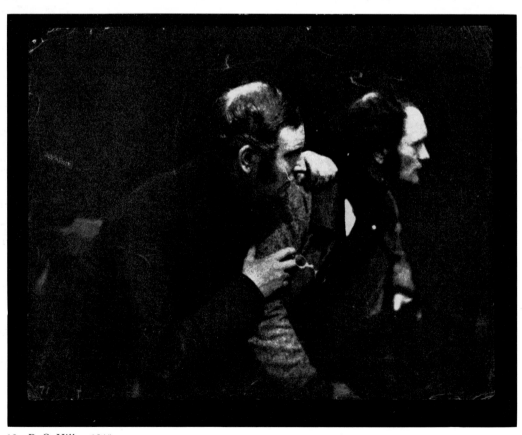

12 D. O. Hill, c. 1845

13　Edgar Degas, c. 1893

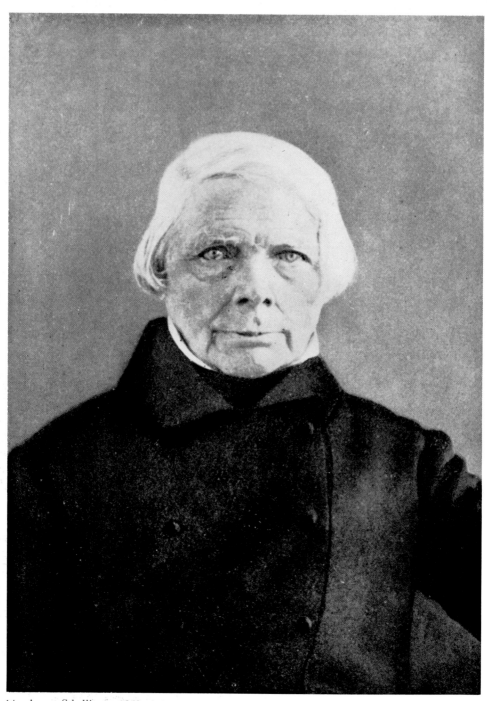

14 Anon., Schelling, c. 1850

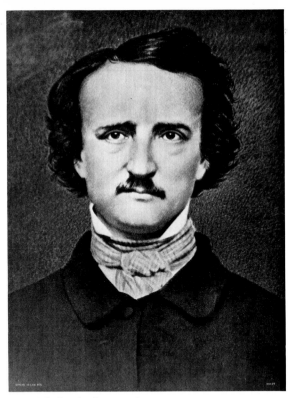

15　M. B. Brady, Poe, c. 1845

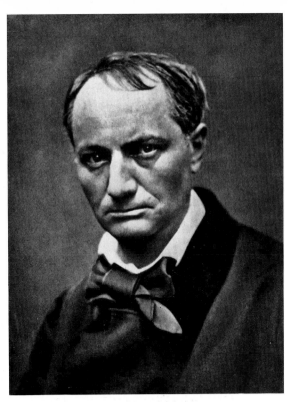

16　E. Carjat, Baudelaire, c. 1862

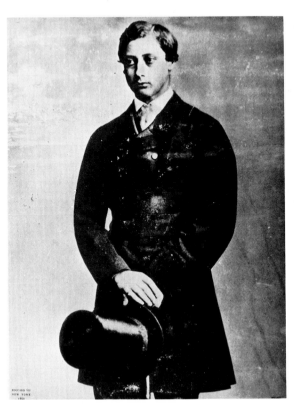

17　M. B. Brady, Edward VII, 1860

18　M. B. Brady, c. 1855

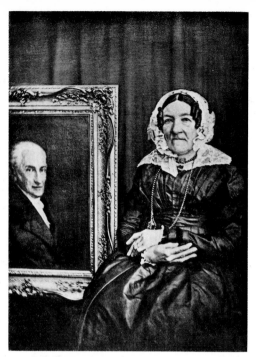

19 C. F. Stelzner, c. 1847

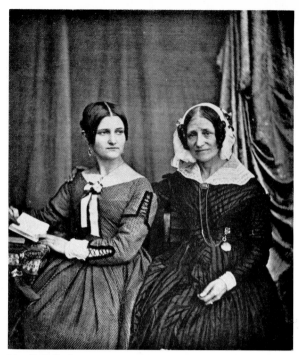

20 C. F. Stelzner, c. 1848

21 LeBas, 1864

22 Nadar, Proudhon, 1853

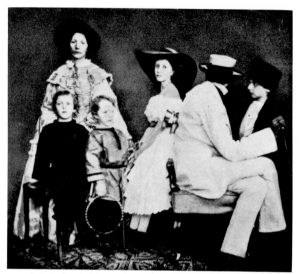

23 Anon., 1859

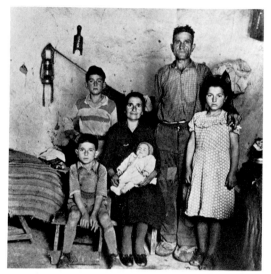

24 Vito Fiorenza, c. 1950

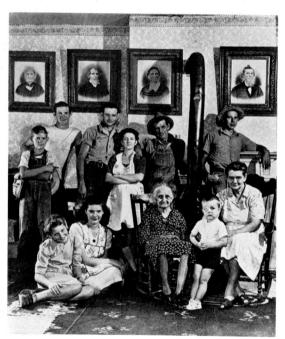

25 Nina Leen, 1948

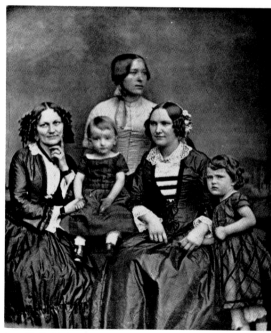

26 C. F. Stelzner, 1855

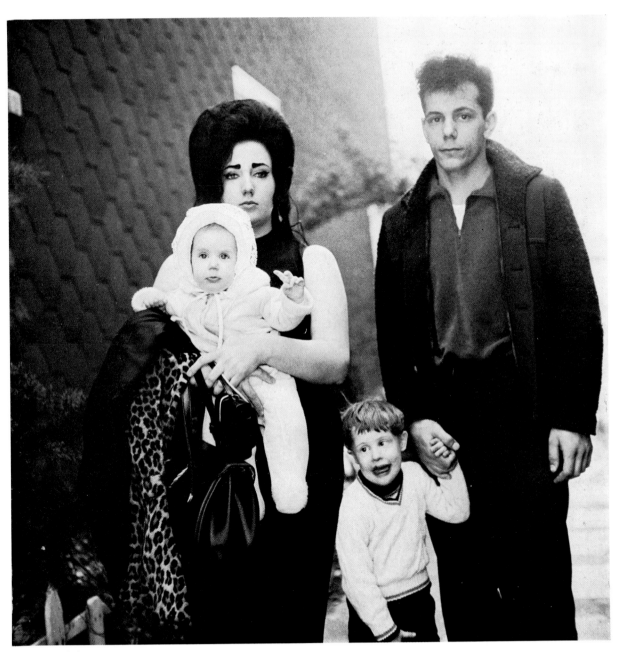

27　Diane Arbus, 1966

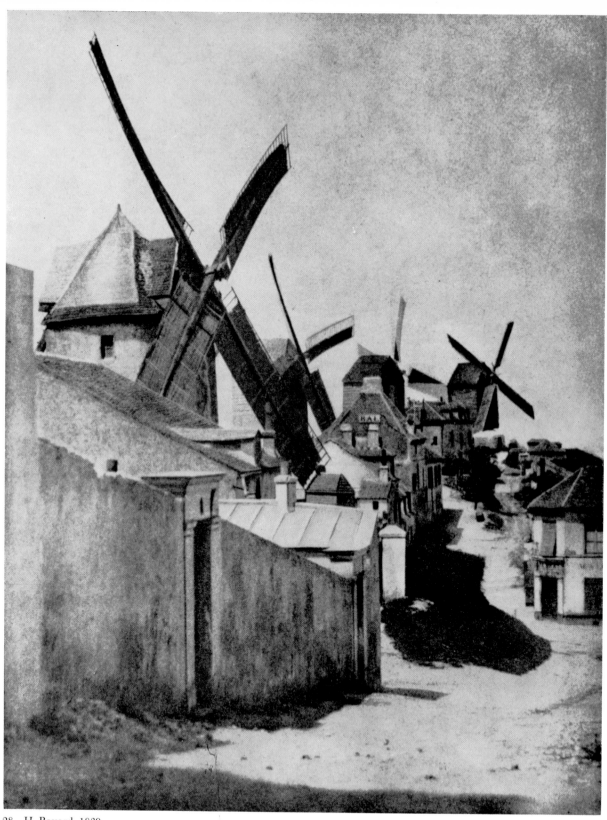

28 H. Bayard, 1839

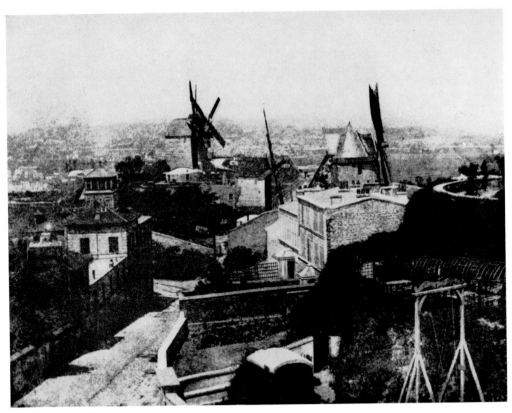

29 H. Bayard, 1842

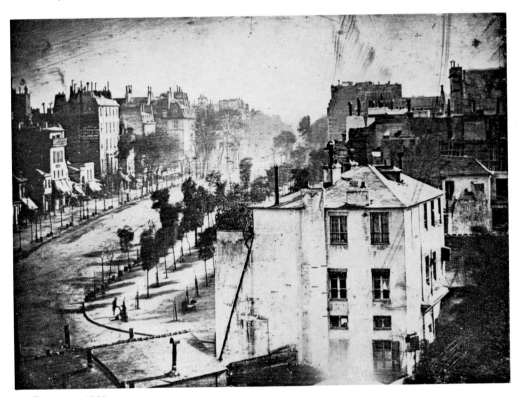

30 Daguerre, 1839

31 H. V. Regnault, c. 1852

32 A. Cuvelier, 1852

33 G. LeGray, 1856

34 Eugène Atget, c. 1900

35 W. H. F. Talbot, c. 1845

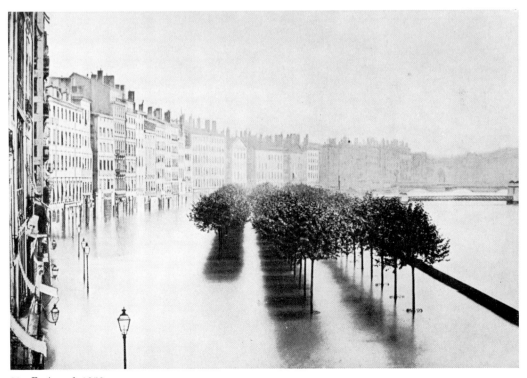

36 Froissard, 1856

37 Francis Frith, Abu Simbel, c. 1856

38 M. B. Brady, c. 1860

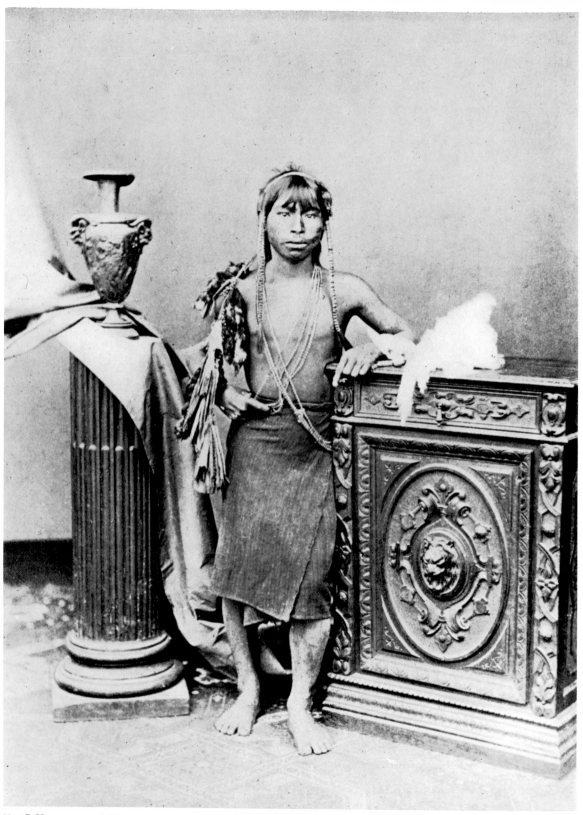

39 C. Hermanos, c. 1868

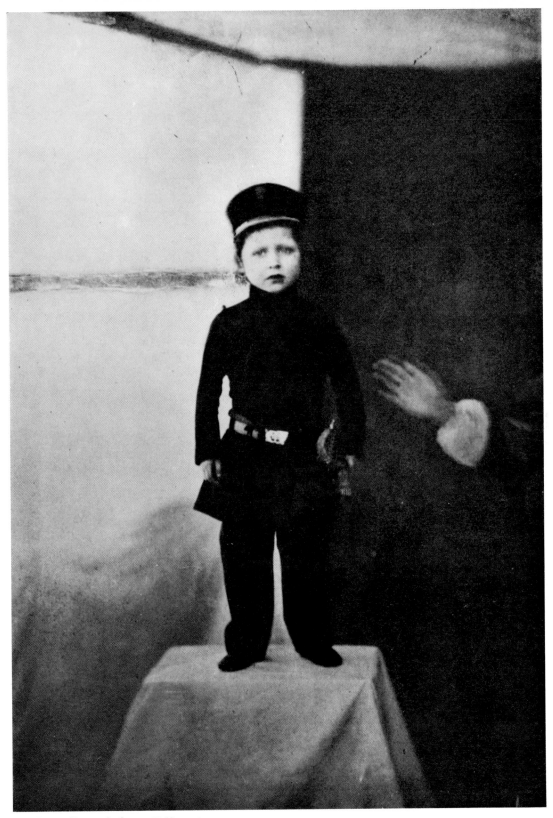

40 Anon., Prince Arthur, c. 1853

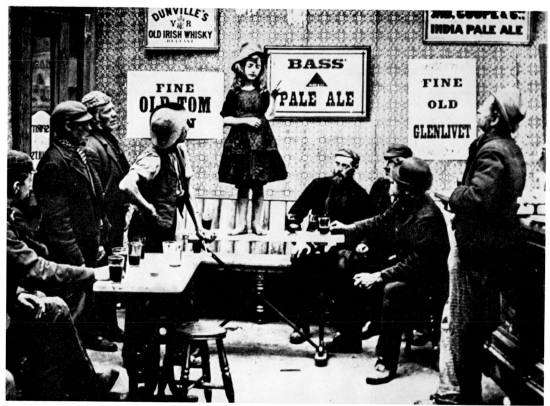

41 Anon., c. 1895

42 D. O. Hill, c. 1845

43 Brassai, 1932

24

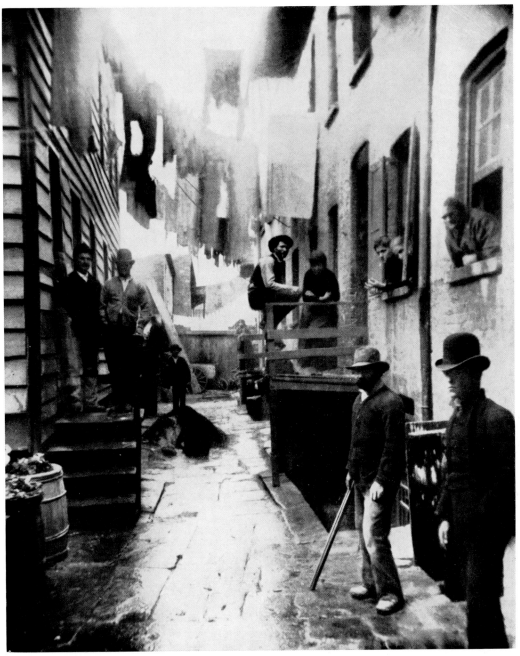

44 Jacob A. Riis, 1888

45　Charles Nègre, 1860

46　Charles Nègre, 1860

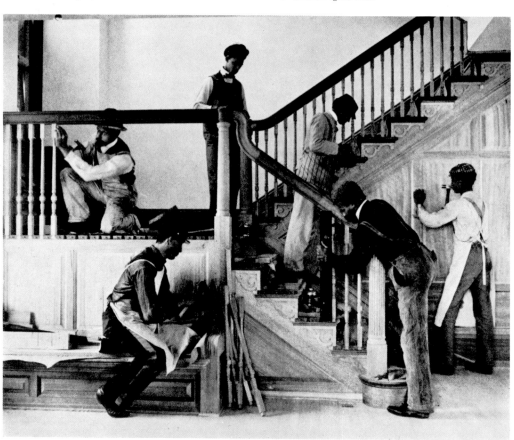

47　Frances B. Johnston, 1899

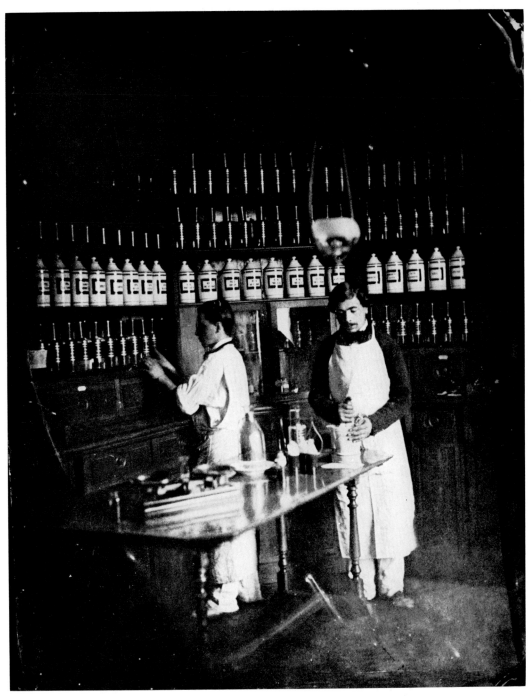

48 Charles Nègre, 1860

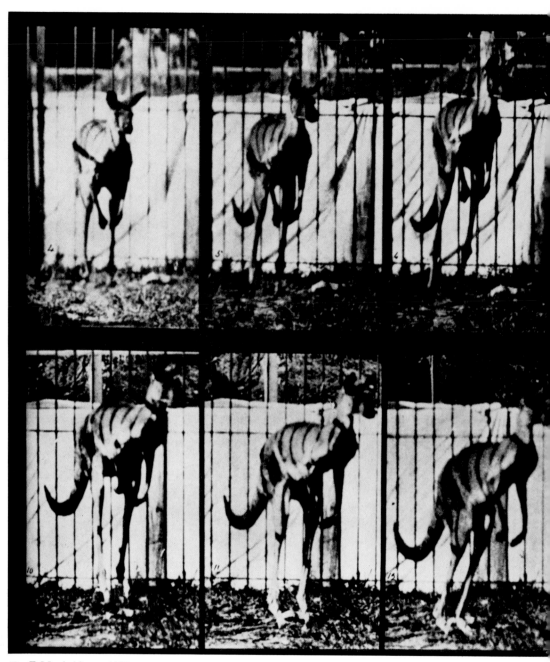

49 E. Muybridge, c. 1885

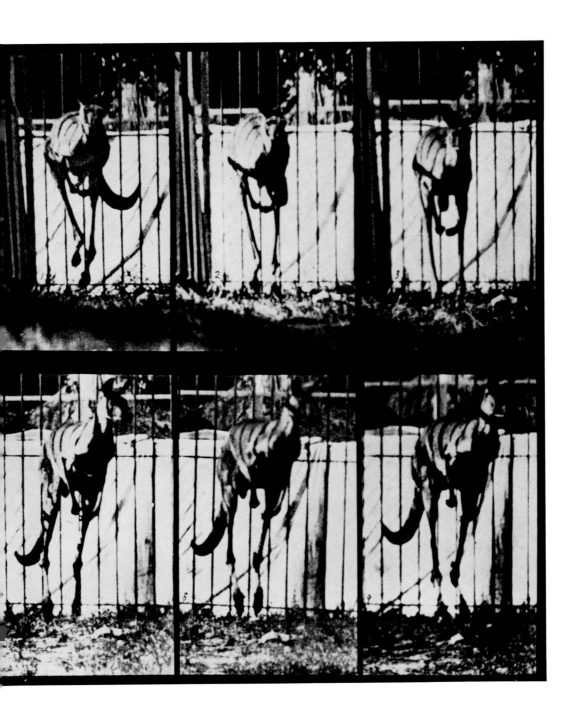

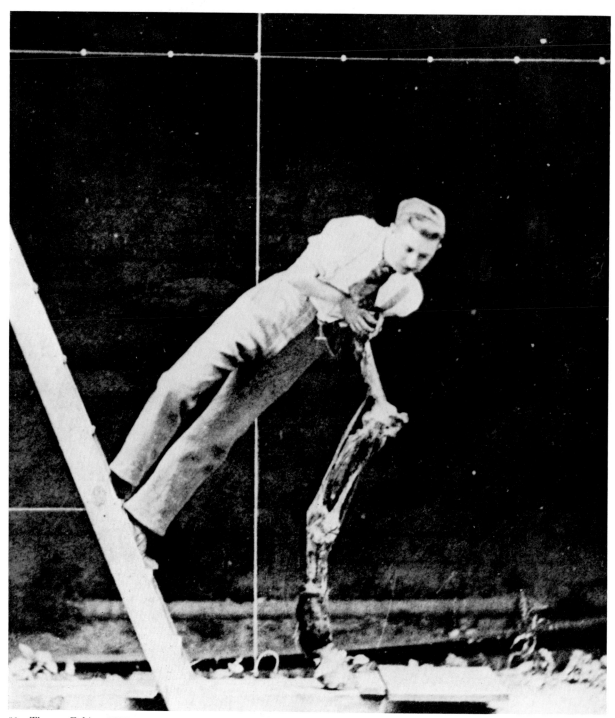

50 Thomas Eakins, 1884

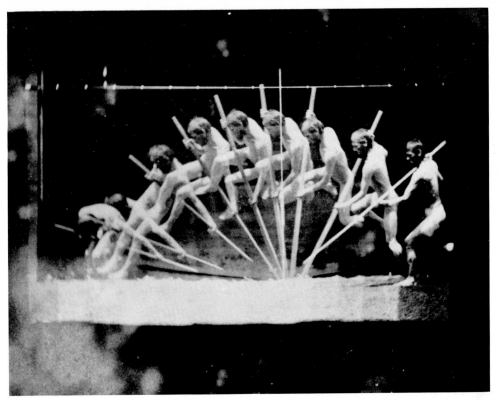

51 Thomas Eakins, 1884

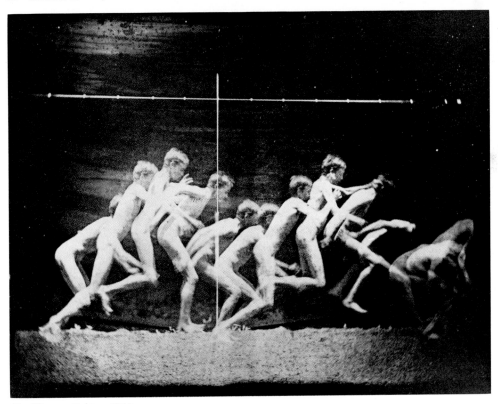

52 Thomas Eakins, 1885

53 E. J. Bellocq, c. 1912

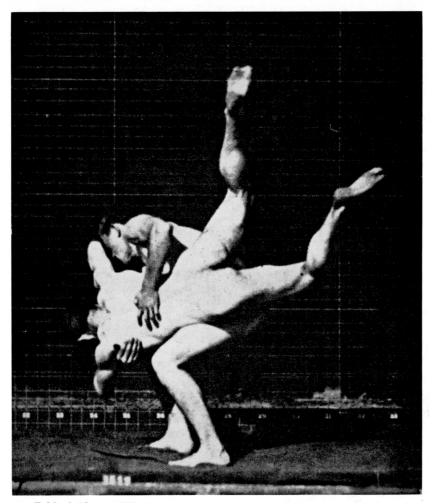

54 E. Muybridge, c. 1885

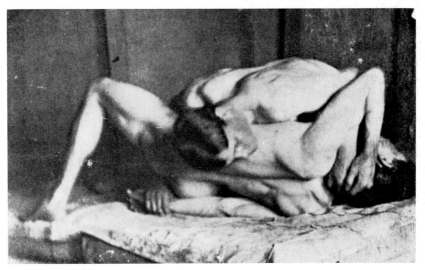

55 Thomas Eakins, c. 1889

33

56 J. H. Lartigue, 1910

57 J. H. Lartigue, 1910

58 J. H. Lartigue, c. 1910

59　D. O. Hill, c. 1845

60　Anon., c. 1870

61 Lewis Carroll, c. 1873

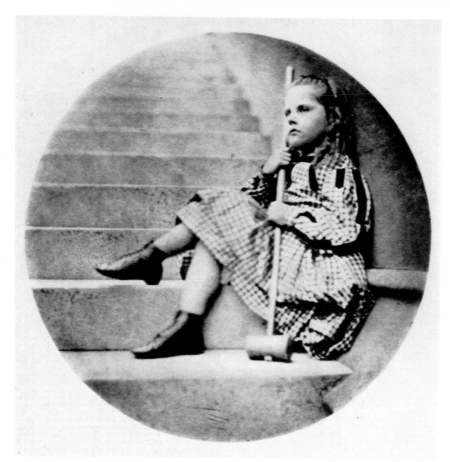

62 Lewis Carroll, 1864

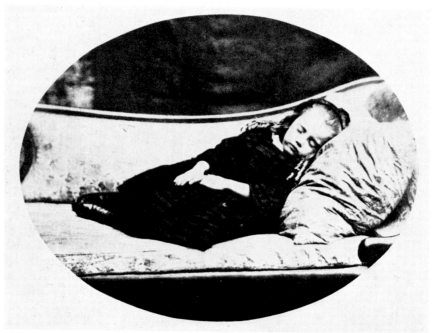

63 Lewis Carroll, c. 1865

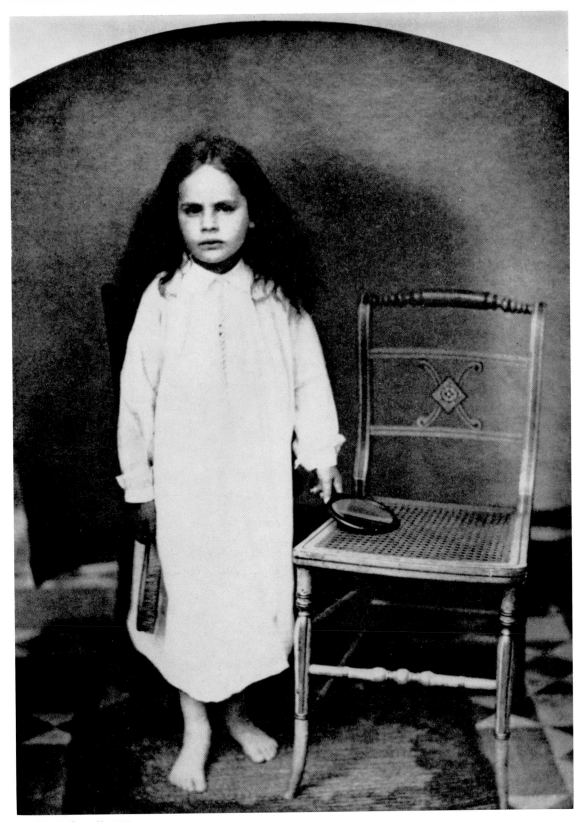

64 Lewis Carroll, 1863

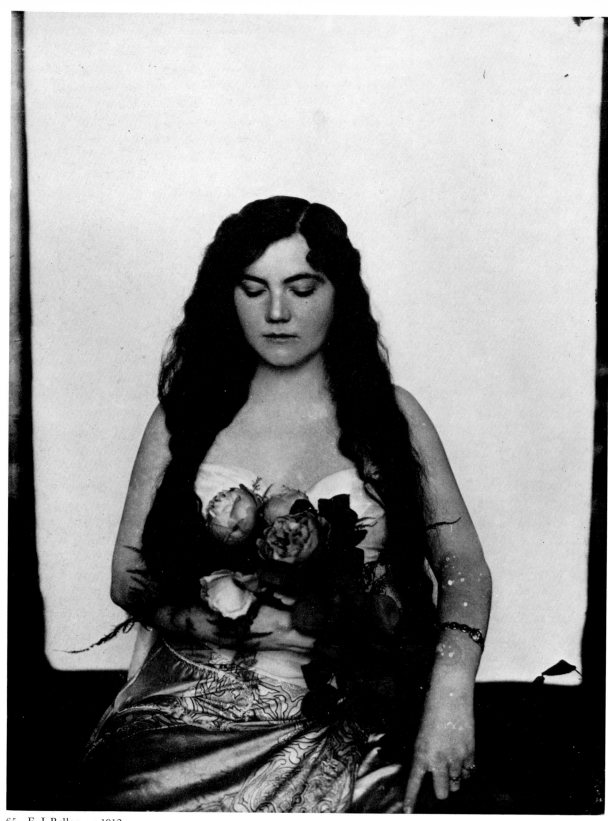

65 E. J. Bellocq, c. 1912

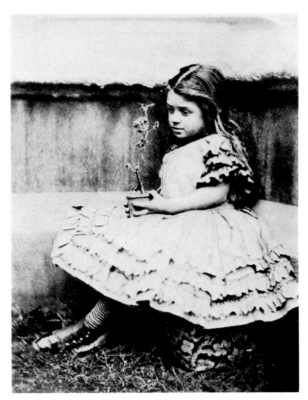

66 Lewis Carroll, 1864

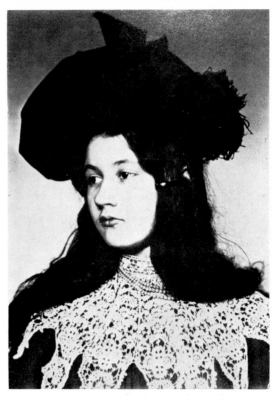

67 Emile Zola, c. 1900

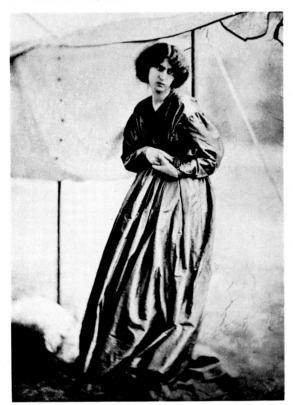

68 D. G. Rossetti, 1865

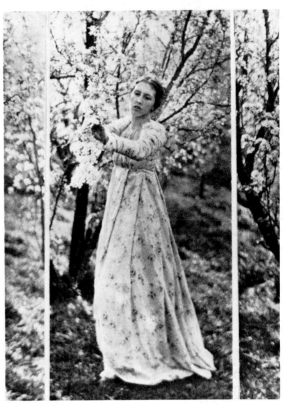

69 C. H. White, 1898

41

70 C. H. White, 1908

71 Thomas Eakins, c. 1888

72 Edouard Boubat, 1959

73 C. H. White, 1898

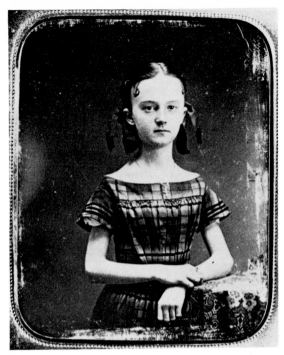

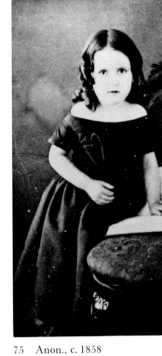

74　Anon., c. 1858

75　Anon., c. 1858

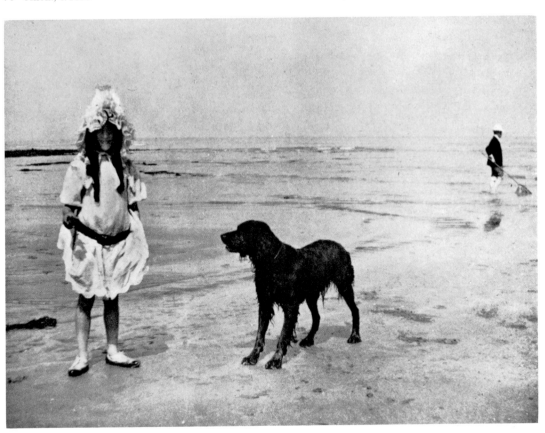

76　J. H. Lartigue, 1906

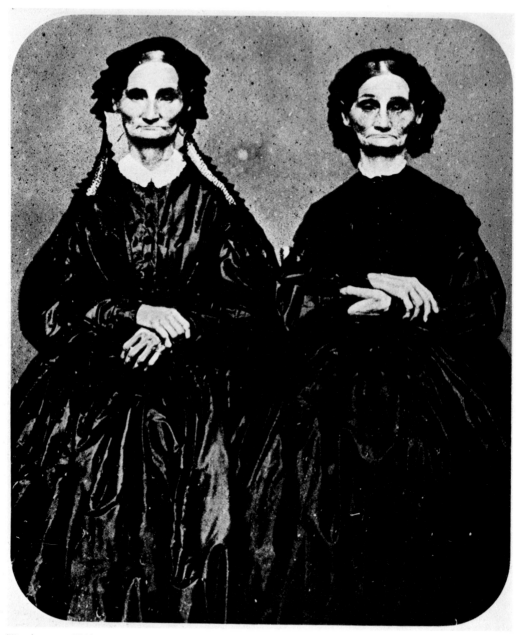

77 Anon., c. 1850

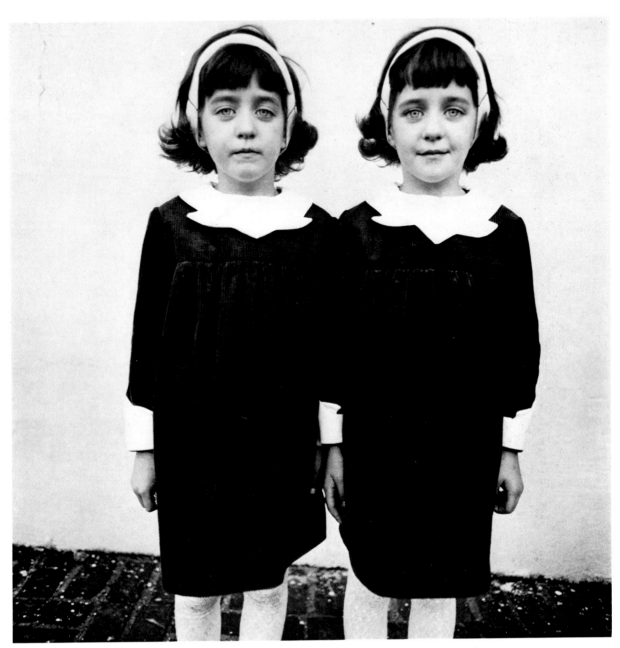

78 Diane Arbus, 1966

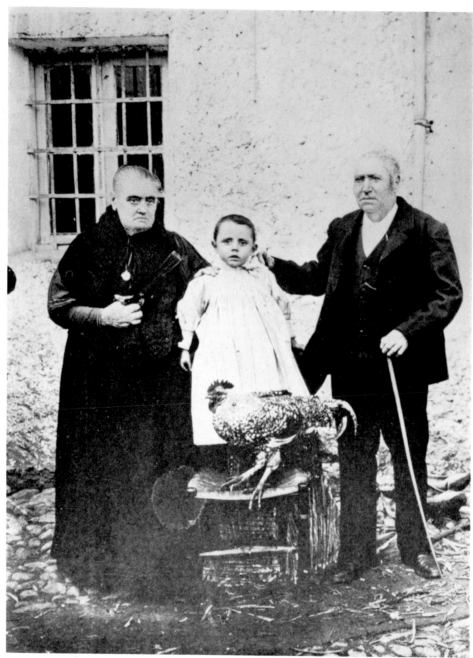

79 Antonio de Ines, 1870

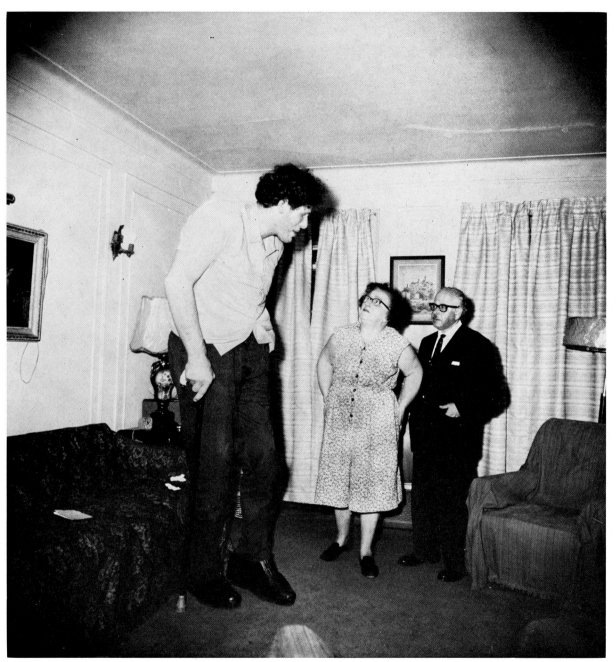

80 Diane Arbus, 1970

81 J. M. Cameron, Herschel, 1867

82 Diane Arbus, 1968

83 August Sander, 1923

84 Anon., 1917

85 Eugène Atget, c. 1910

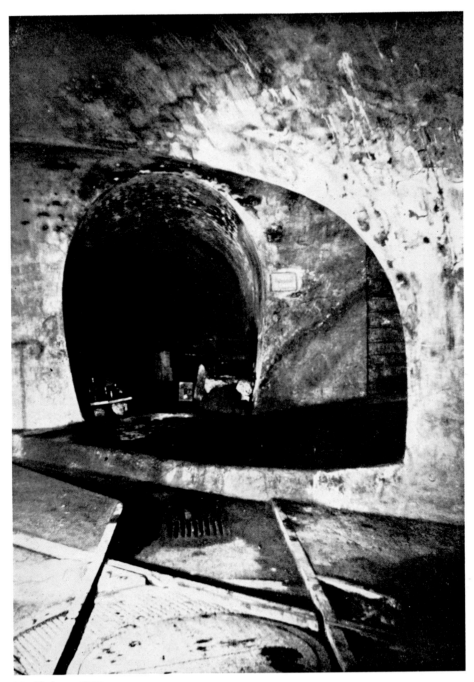

86 Nadar, c. 1860

87 Walker Evans, c. 1931

88 Bool, 1868

89 Anon., c. 1880

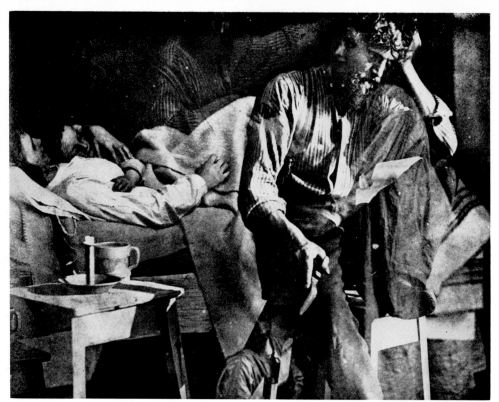

90 O. G. Rejlander, 1860

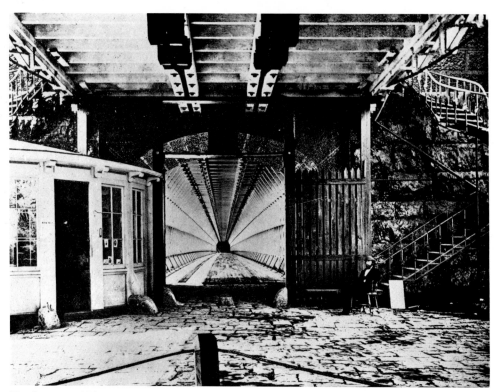

91 Anon., c. 1865

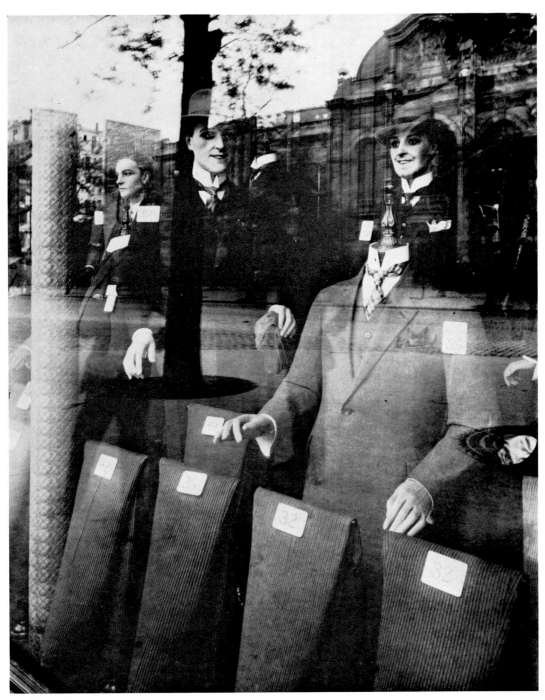

92 Eugène Atget, c. 1910

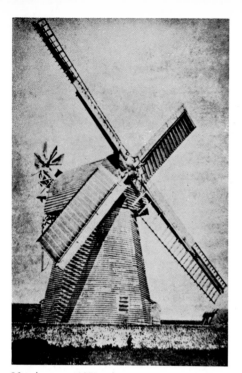

93 Anon., c. 1870

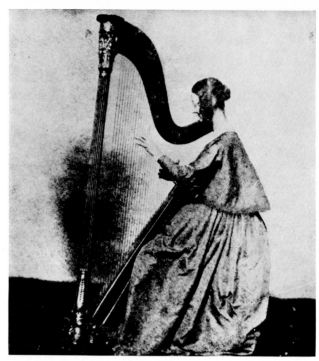

94 W. H. F. Talbot, c. 1842

95 B. B. Turner, c. 1852

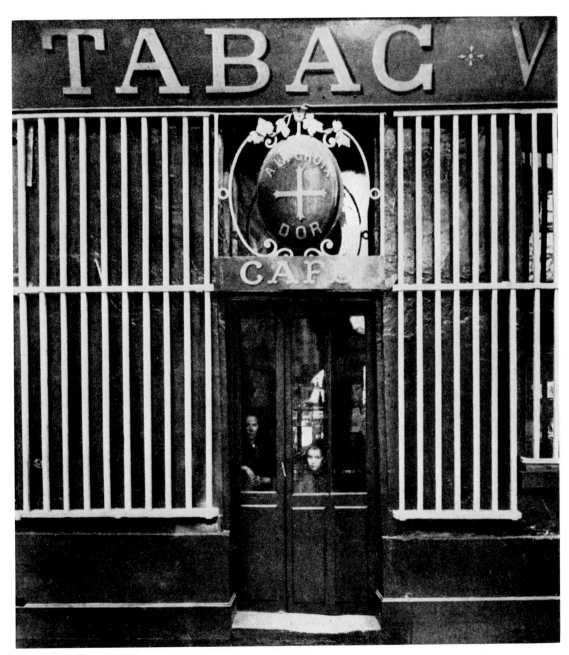

96 Eugène Atget, c. 1900

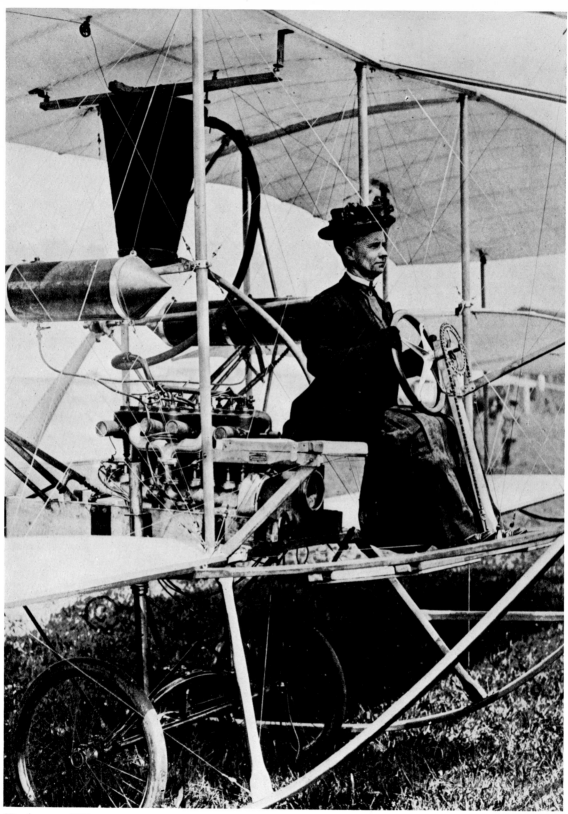

97 Anon., c. 1900

98 J. H. Lartigue, 1905

99 J. H. Lartigue, 1904

100 Seidenstücker, 1930

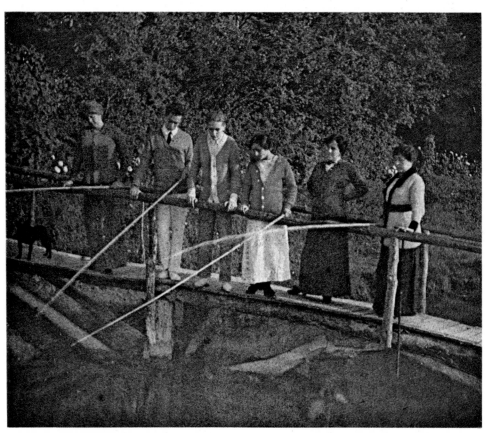

101 J. H. Lartigue, 1913

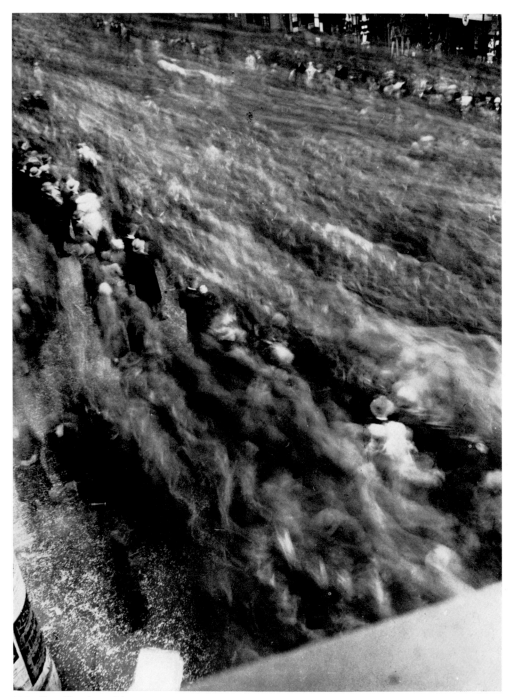

102 R. v. Koenigswald, 1930

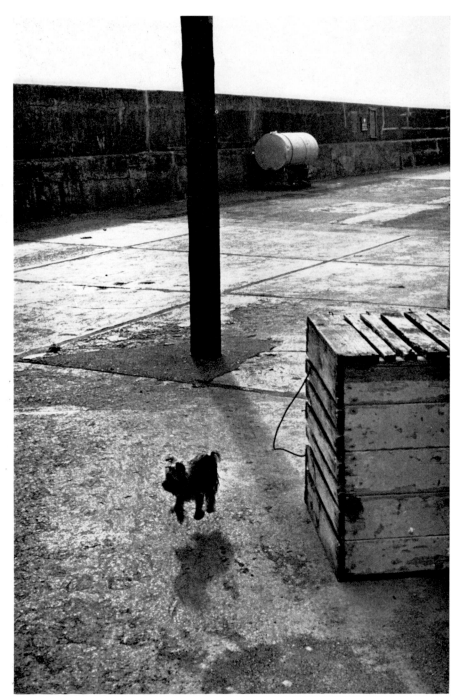

103 Elliot Erwitt, 1968

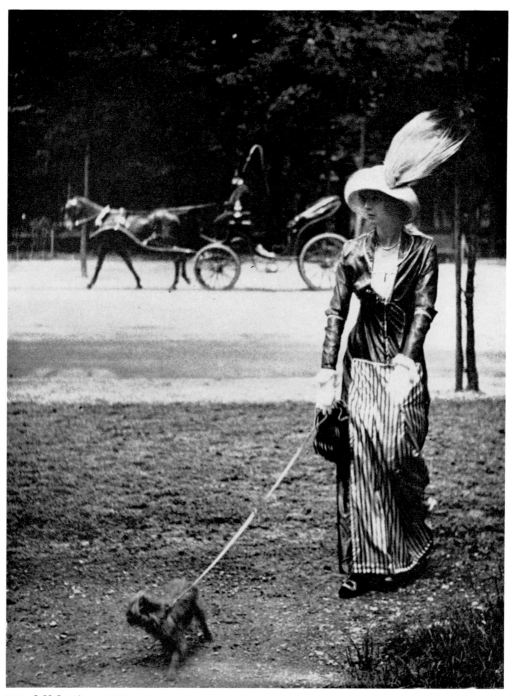

104 J.H. Lartigue, 1912

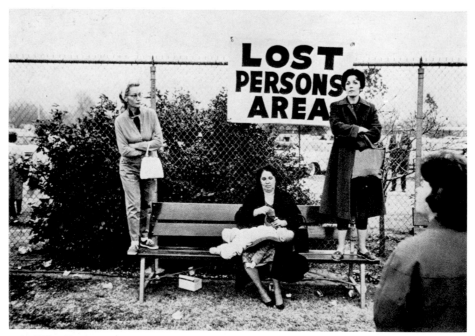

105 Elliot Erwitt, 1963

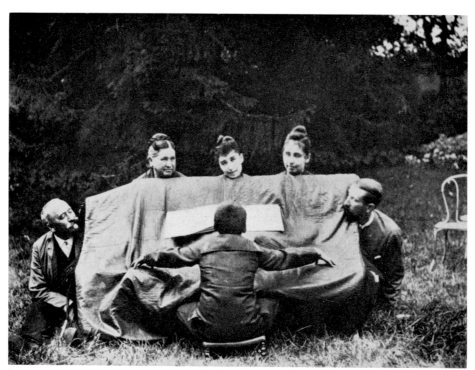

106 Anon., c. 1895

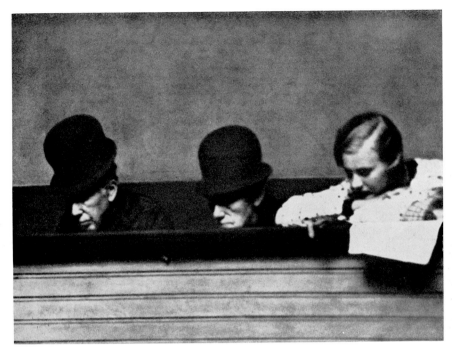

107 Erich Salomon, c. 1930

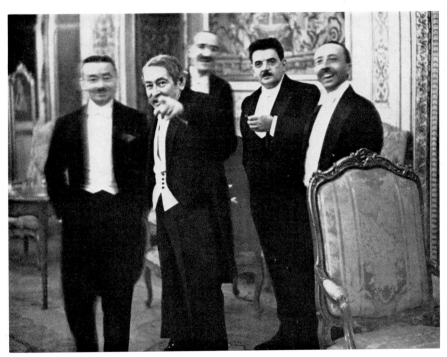

108 Erich Salomon, 1931

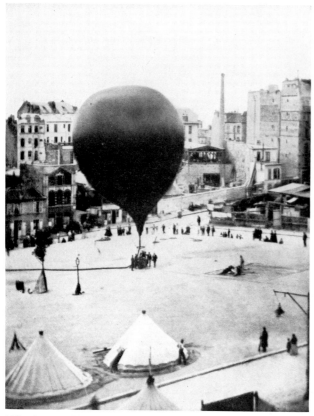

109 Anon., 1870

110 Robert Capa, 1945

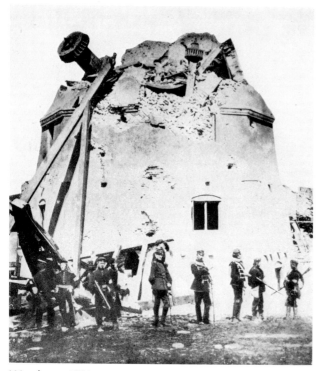

111 Anon., 1864

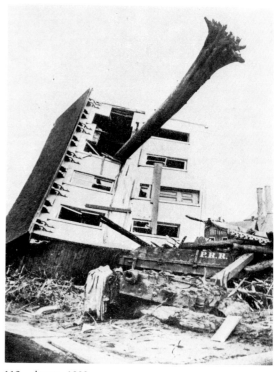

112 Anon., 1889

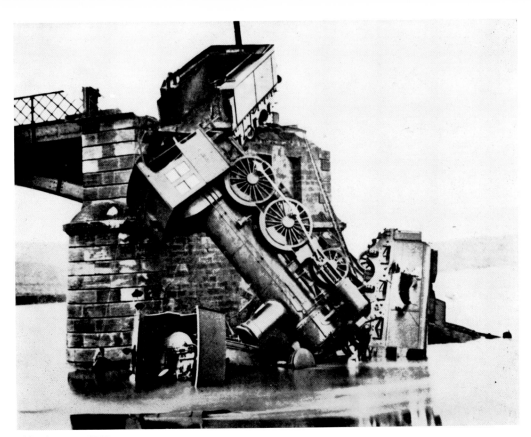

113 Anon., c. 1870

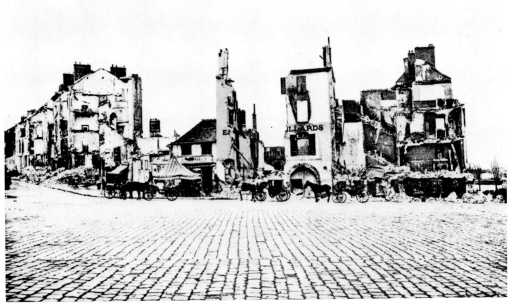

114 Anon., St. Cloud, 1871

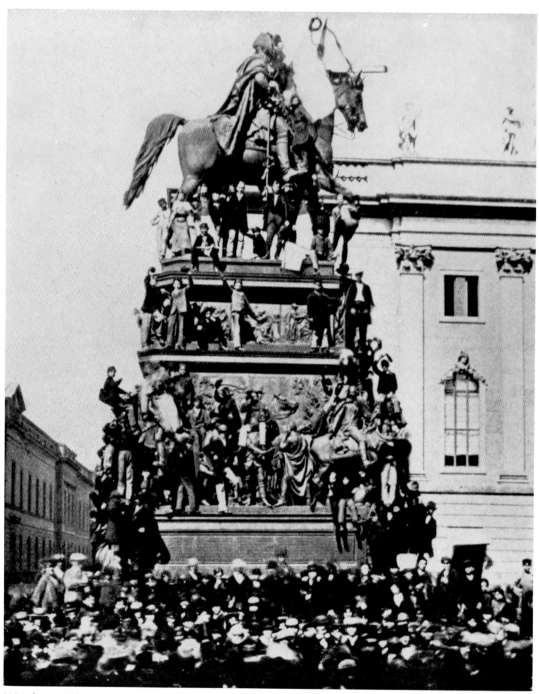

115 Anon., 1870

116 Anon., 1910

117 Giuseppe Primoli, c. 1890

118 Max Ernst, c. 1920

119 Eugène Atget, c. 1910

120 Giuseppe Primoli, c. 1895

121 Walker Evans, 1968

122 Walker Evans, 1945

123 André Kertész, 1926

124 André Kertész, 1926

125 Anon., c. 1910

126 Eugène Atget, c. 1910

127 Eugène Atget, c. 1910

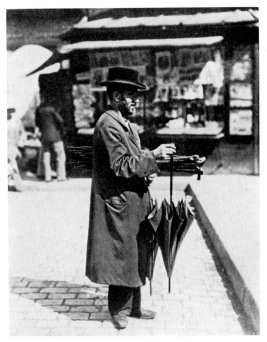

128 Eugène Atget, c. 1910

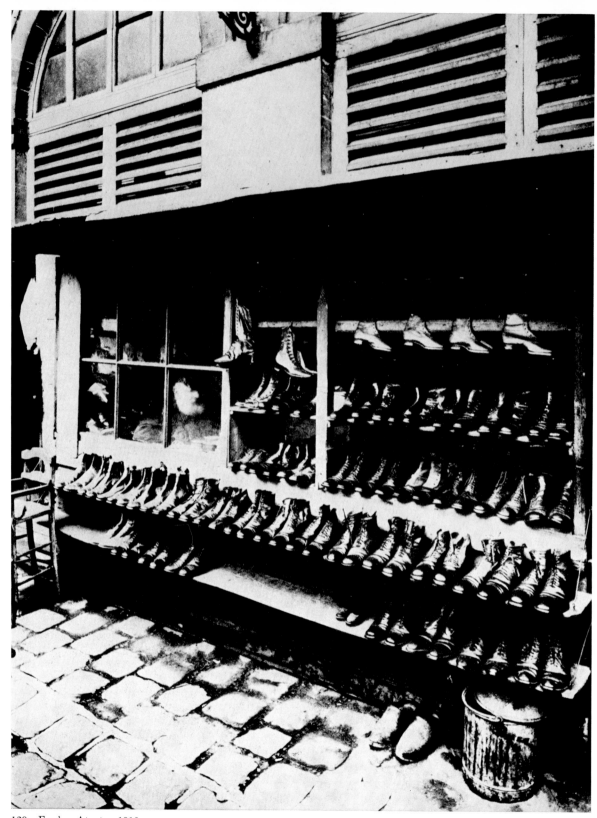

129 Eugène Atget, c. 1910

130 H. Cartier-Bresson, 1934

131 A. Renger-Patzsch, c. 1925

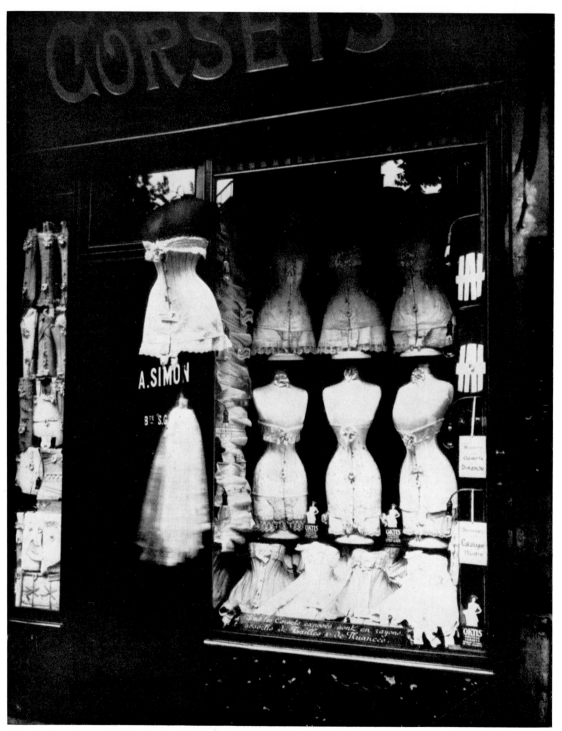

132 Eugène Atget, c. 1910

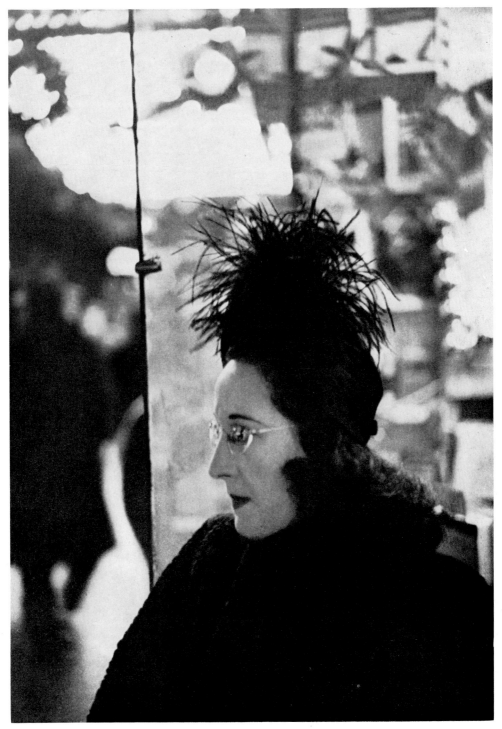

133 H. Cartier-Bresson, 1947

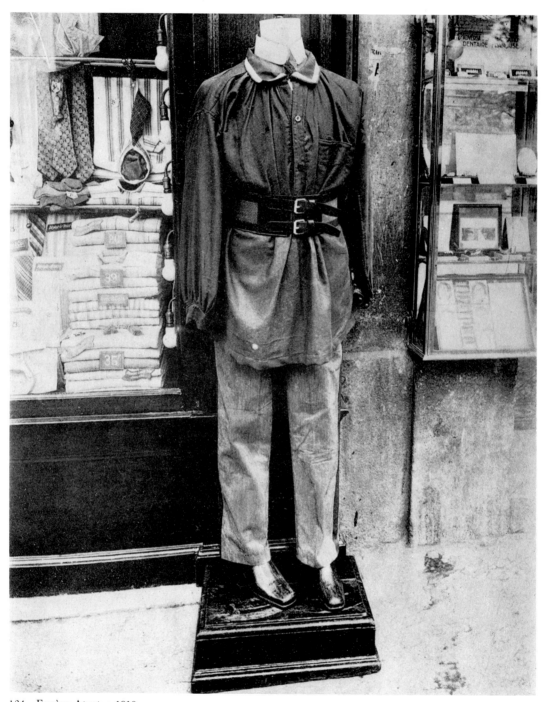

134　Eugène Atget, c. 1910

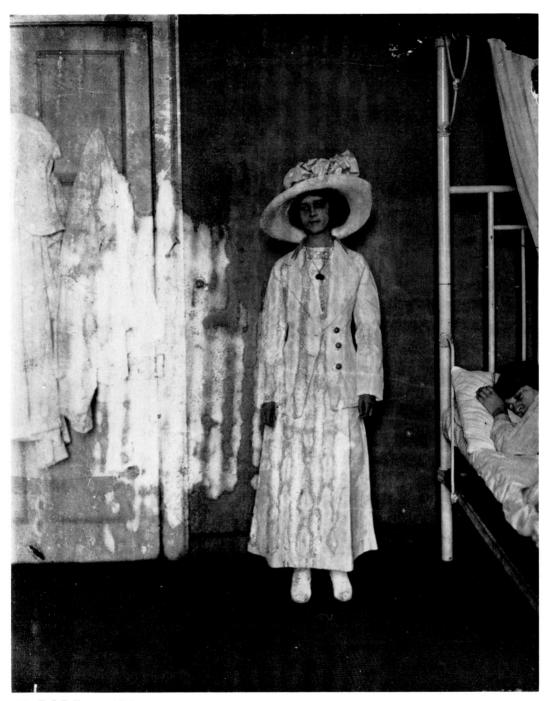

135 E. J. Bellocq, c. 1912

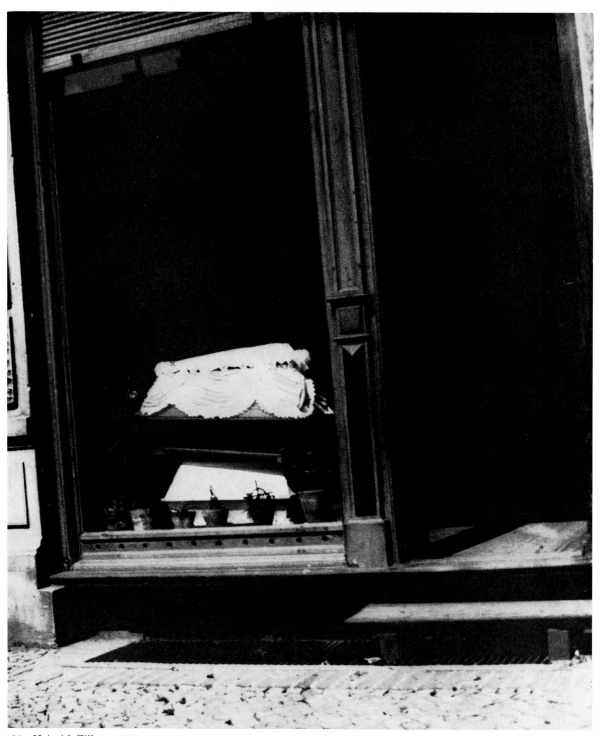

136 Heinrich Zille, c. 1910

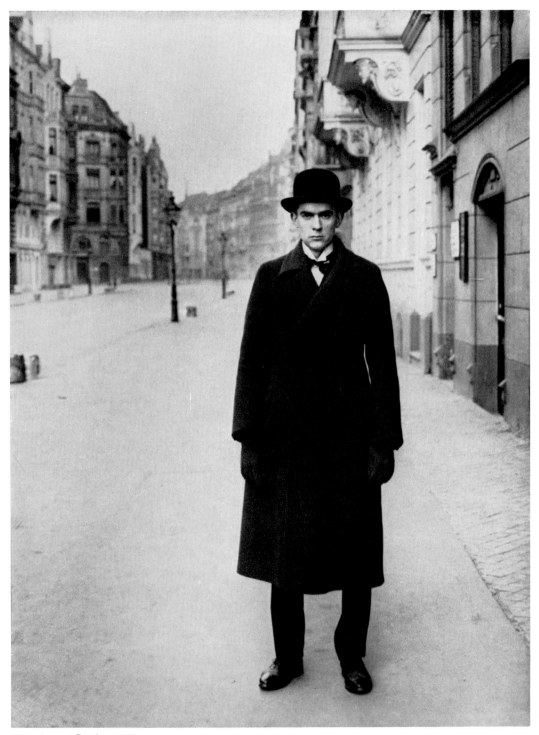

137 August Sander, 1927

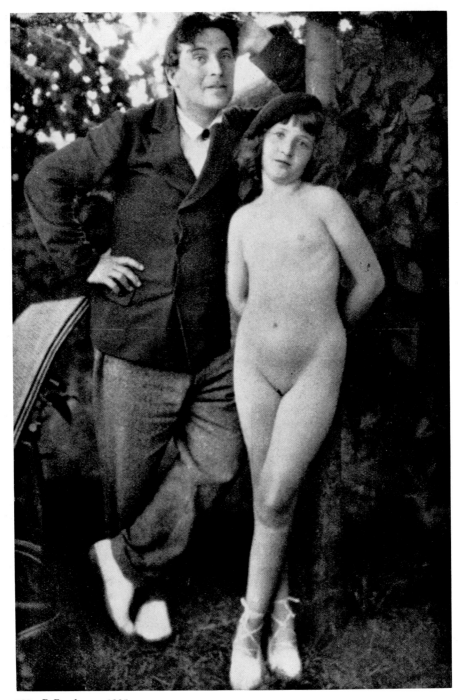

138　P. Barchan, c. 1925

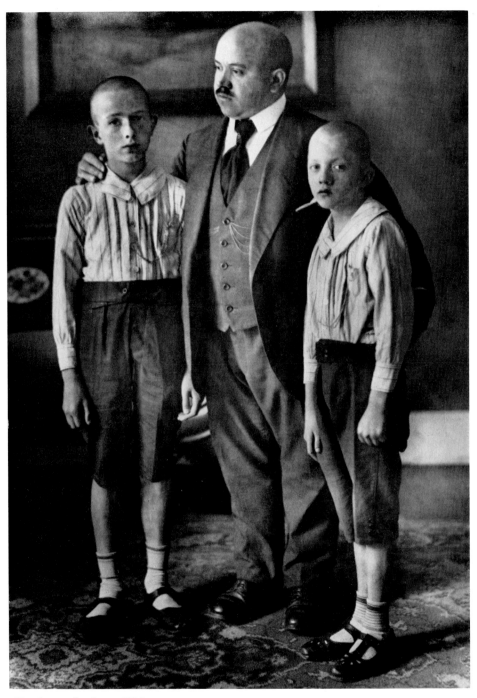

139 August Sander, c. 1925

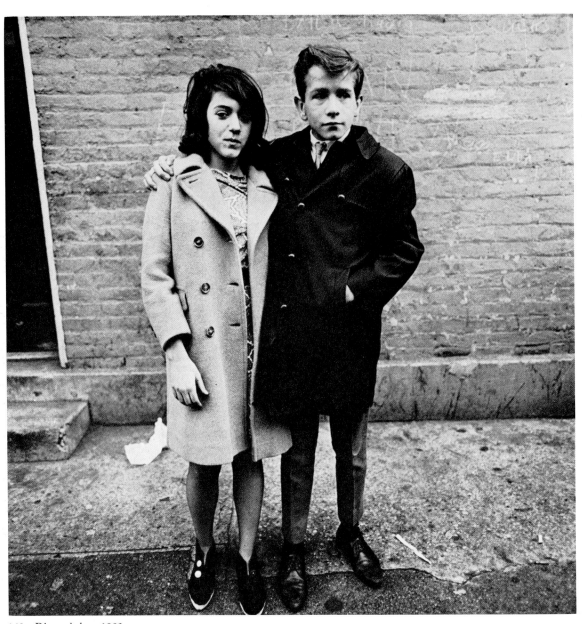

140 Diane Arbus, 1963

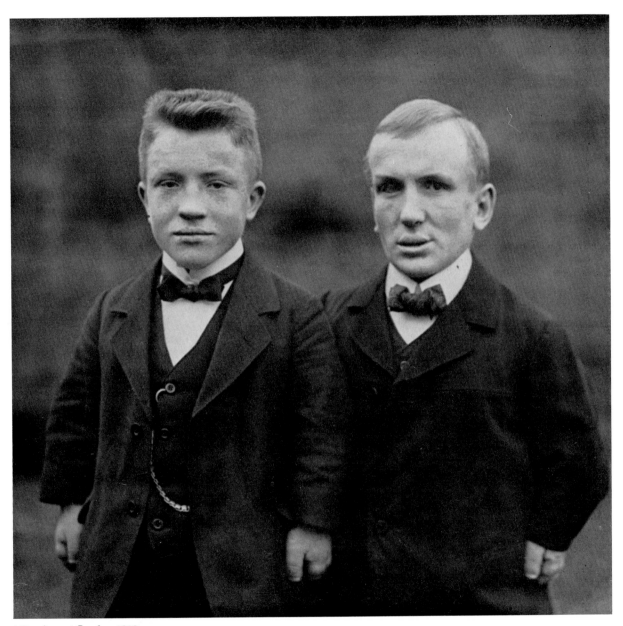

141 August Sander, 1912

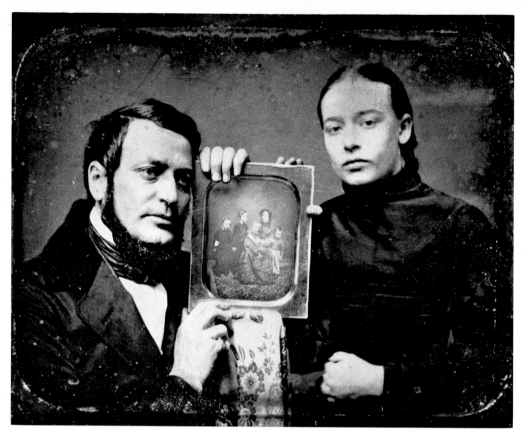

142 Anon., c. 1850

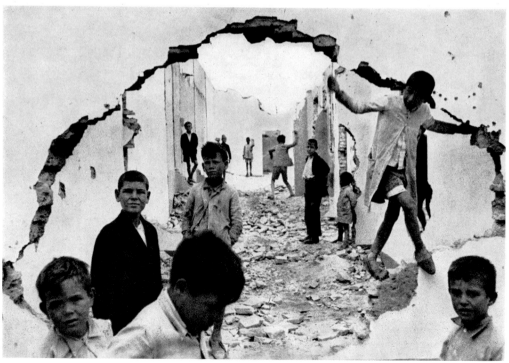

143 H. Cartier-Bresson, 1933

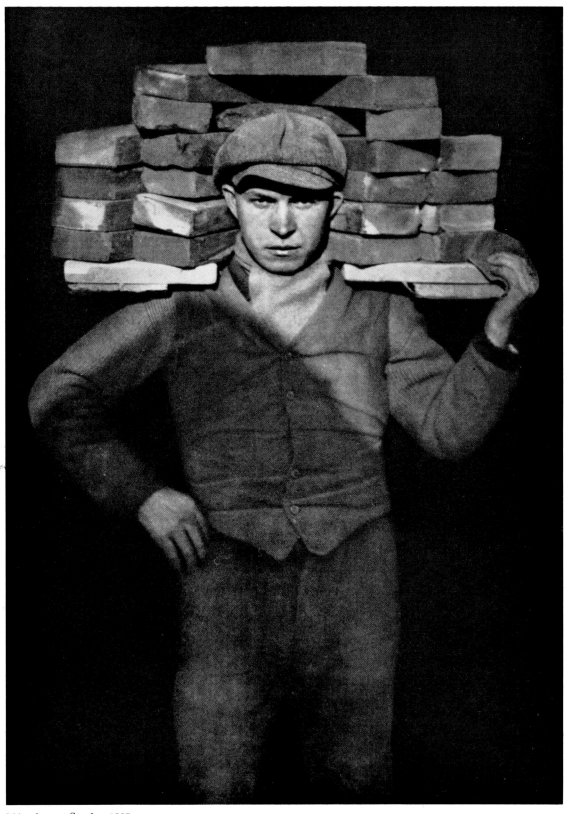

144 August Sander, 1927

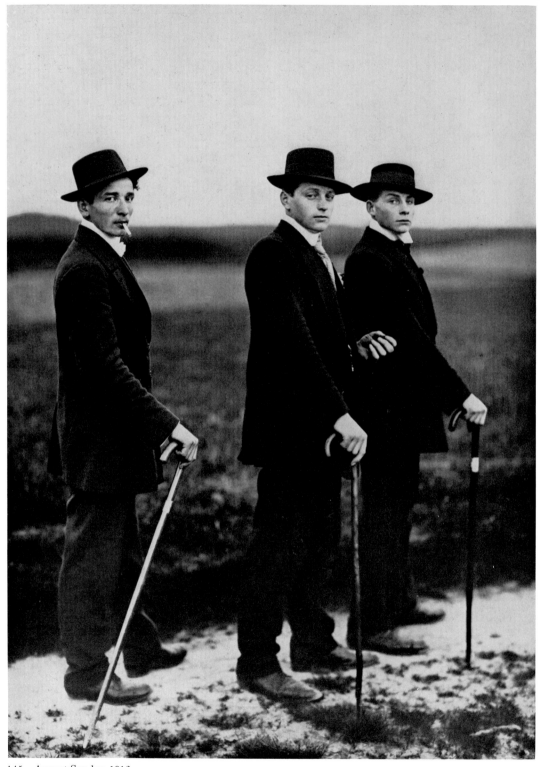

145 August Sander, 1913

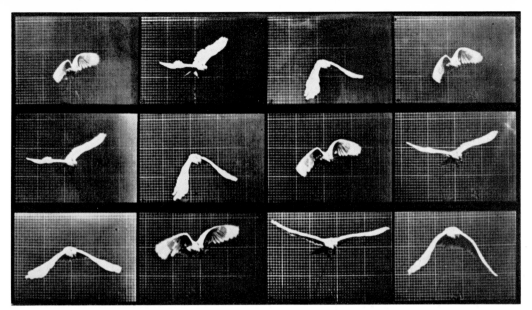

146 E. Muybridge, c. 1885

147 Danny Lyon, 1962

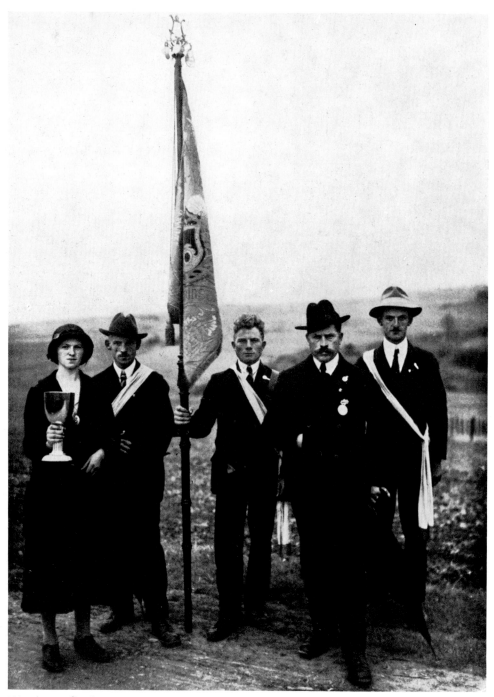

148 August Sander, 1927

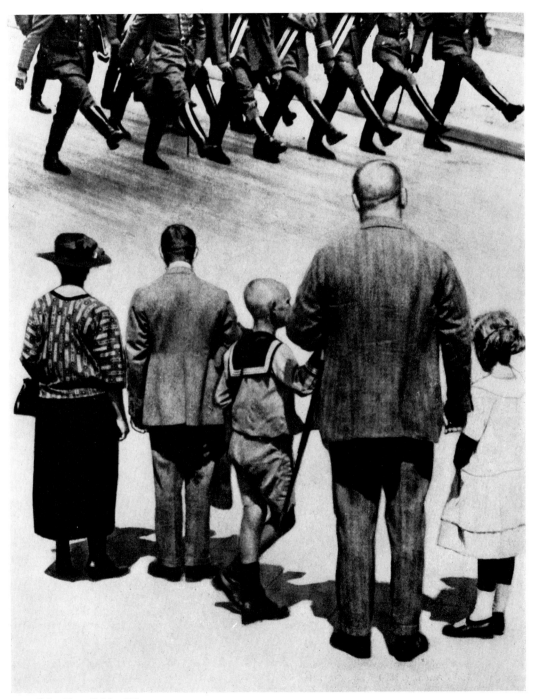

149 John Heartfield, 1929

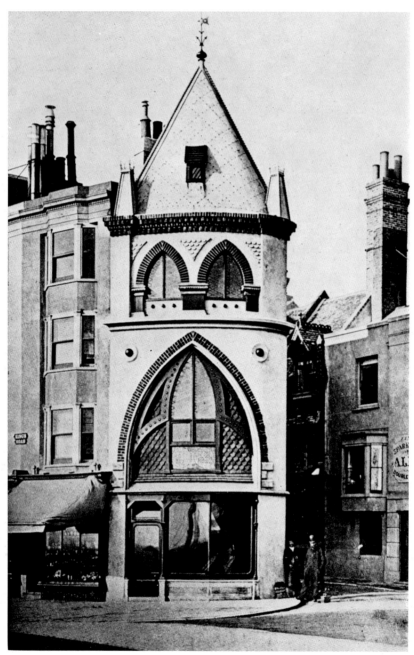

150 Anon., c. 1870

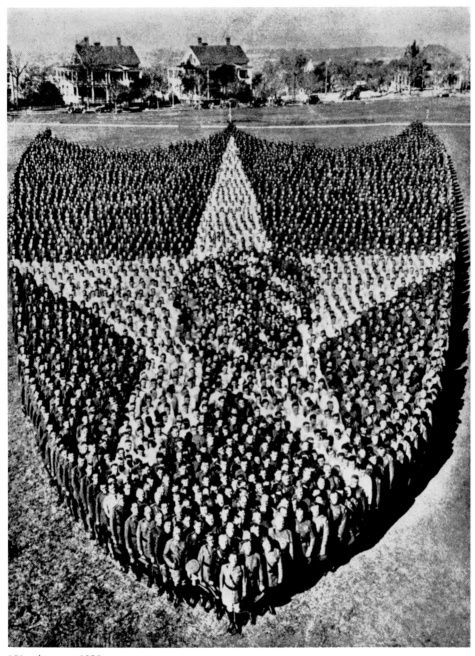

151 Anon., c. 1925

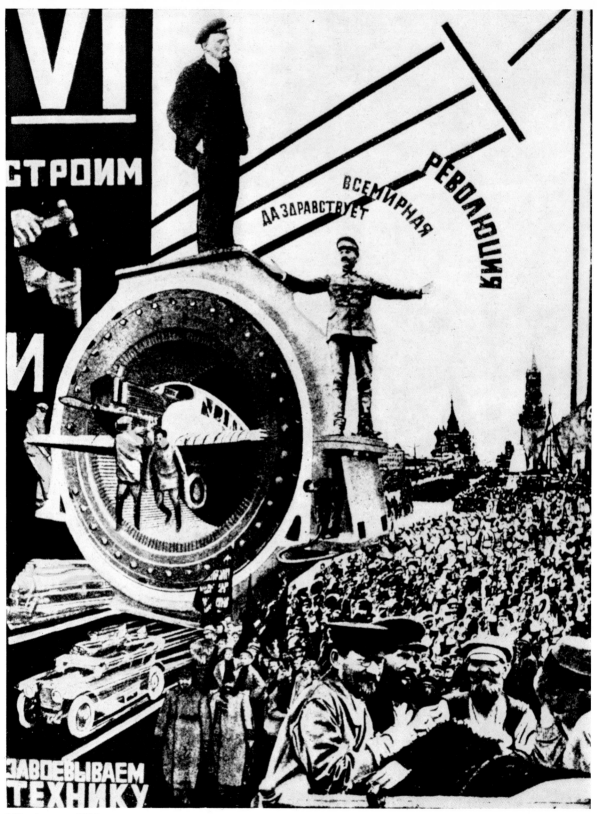

Да здравствует всемирная революция

VI СТРОИМ

ЗАВОЕВЫВАЕМ ТЕХНИКУ

152 Anon., c. 1925

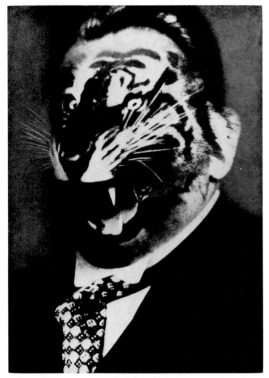

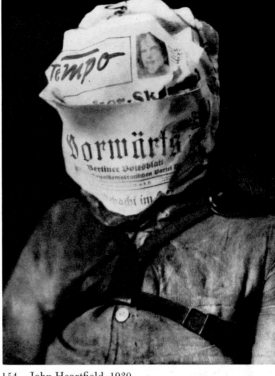

153 John Heartfield, 1931

154 John Heartfield, 1930

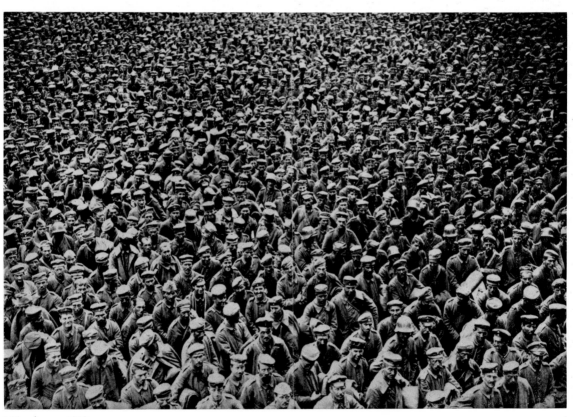

155 Anon., 1918

156 Anon., c. 1925

157 H. Cartier-Bresson, 1954

158 Anon., c. 1920

159 Anon., 1958

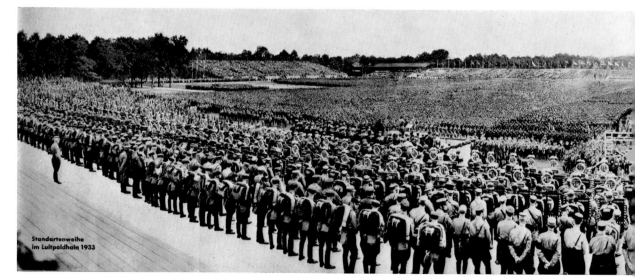

160 Anon., 1933

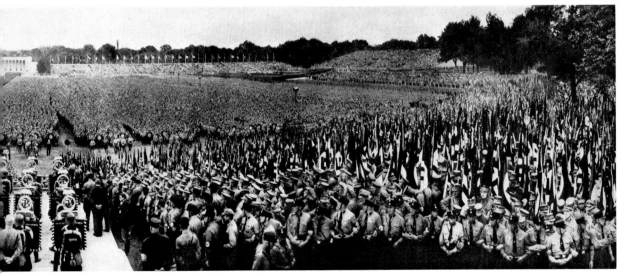

161 Anon., c. 1925

162 Anon., c. 1925

163 A. Renger-Patzsch, c. 1925

164 Elliot Erwitt, 1964

165 Guy Bourdin, 1956

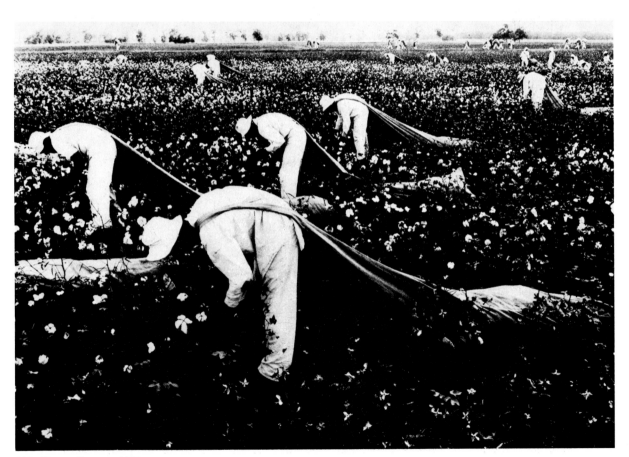

166 Danny Lyon, c. 1970

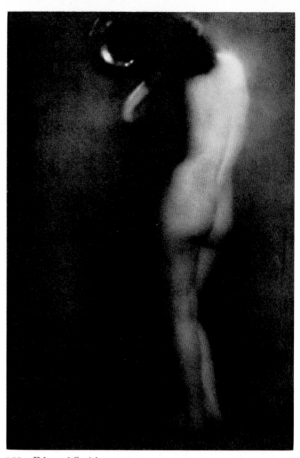

167 Edward Steichen, 1898

168 Edward Steichen, 1902

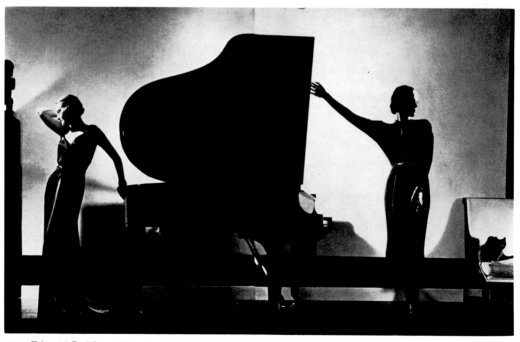

169 Edward Steichen, 1934

170 Edward Steichen, c. 1922

171 Edward Steichen, c. 1922

172 Edward Steichen, 1935

173 Hoyningen Huené, c. 1930

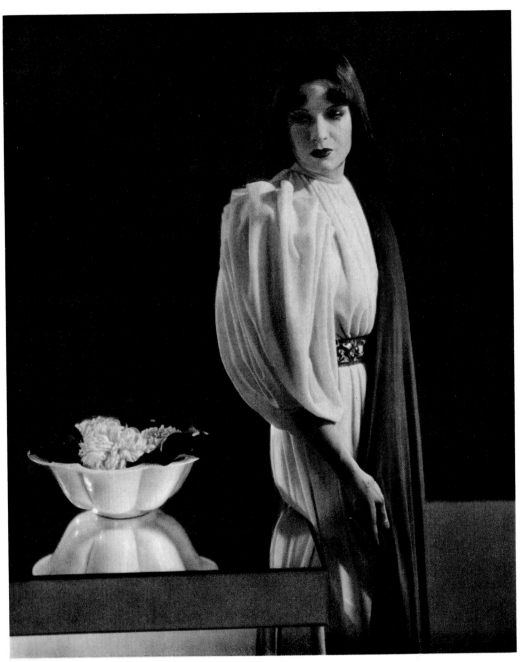

174 Edward Steichen, 1928

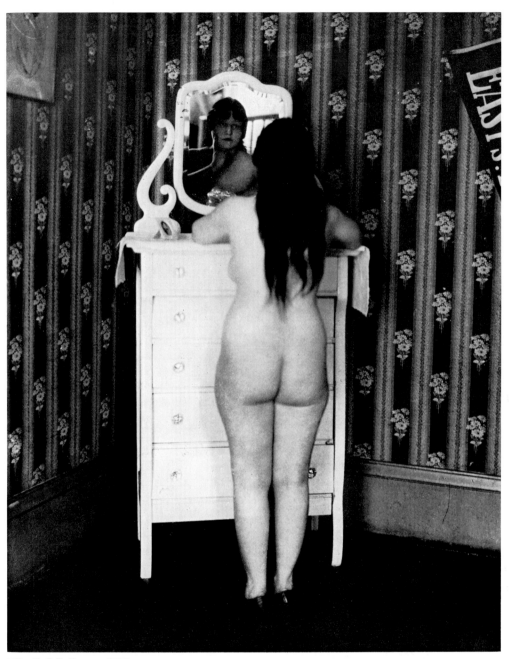

175 E. J. Bellocq, c. 1912

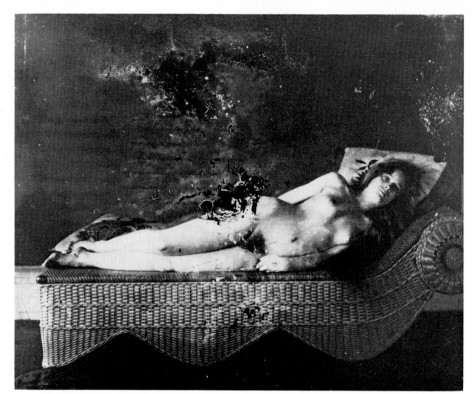

176 E. J. Bellocq, c. 1912

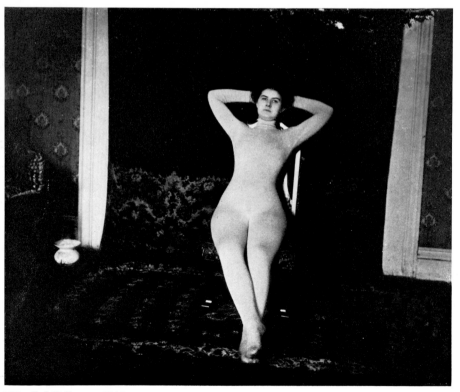

177 E. J. Bellocq, c. 1912

178 Hans Bellmer, 1934

179 Hans Bellmer, 1934

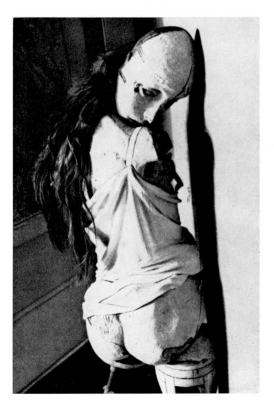

180 Hans Bellmer, 1934

181 Hans Bellmer, 1934

182 Willi Baumeister, c. 1928

183 Willi Baumeister, c. 1928

184 David Hockney, c. 1965

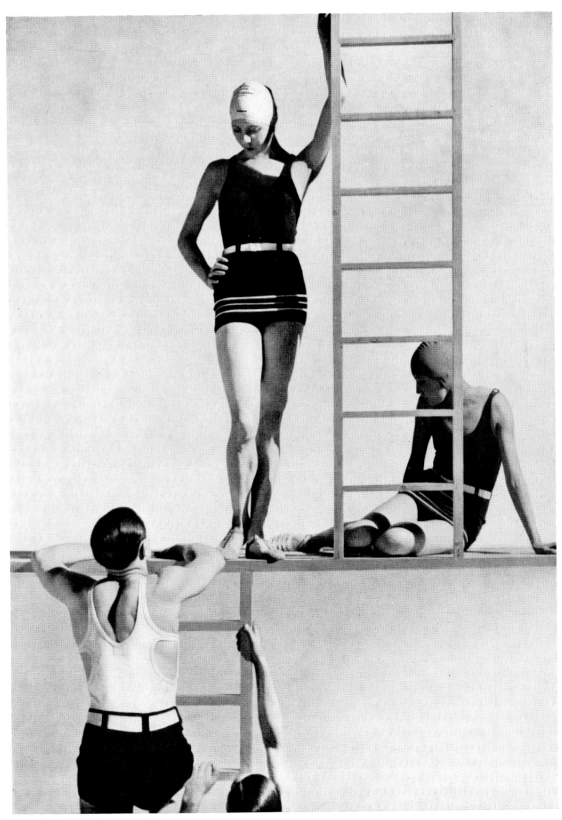

185 Hoyningen Huené, c. 1930

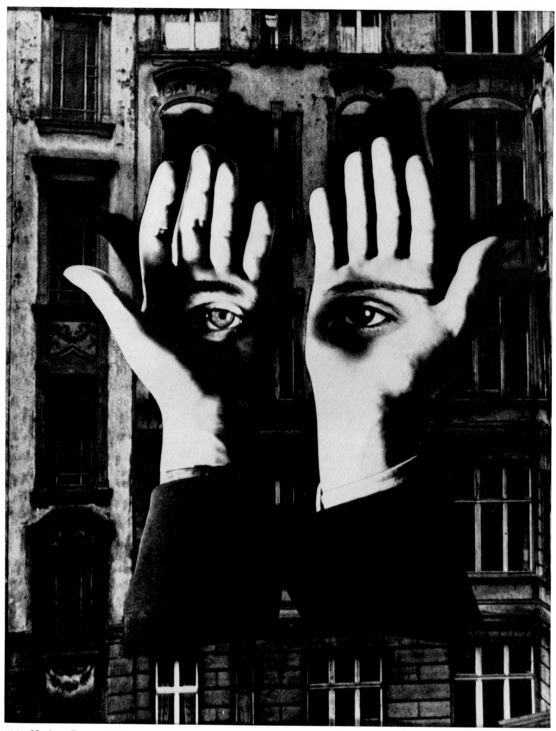

186 Herbert Bayer, 1932

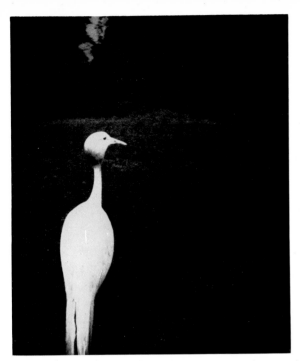

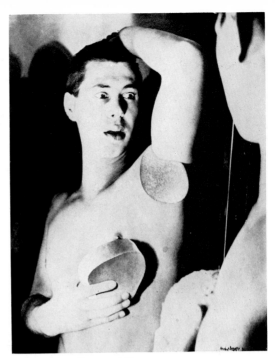

187　Bill Brandt, 1932

188　Herbert Bayer, 1932

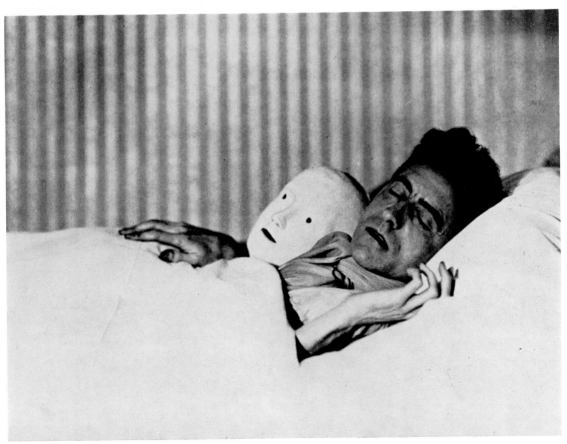

189　Berenice Abbott, Cocteau, c. 1930

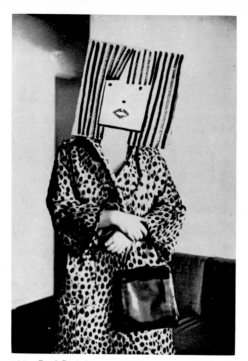

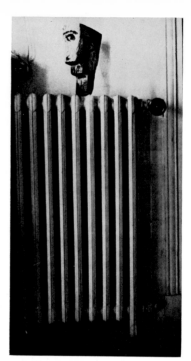

190 Saul Steinberg, c. 1968

191 Brassai, 1943

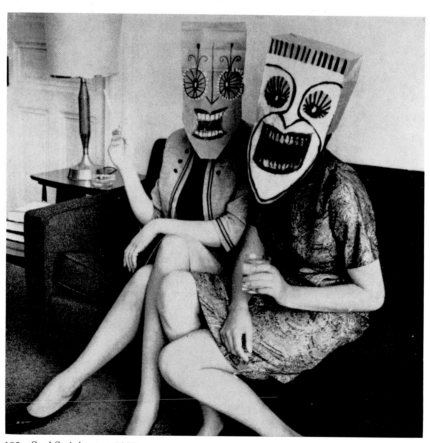

192 Saul Steinberg, c. 1968

193 Lee Friedlander, c. 1968

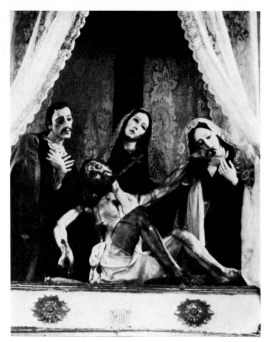

194 Paul Strand, 1933

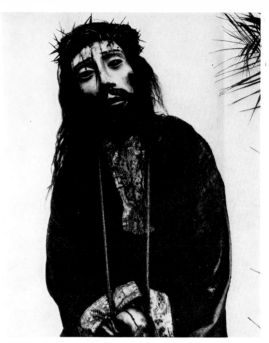

195 Paul Strand, 1933

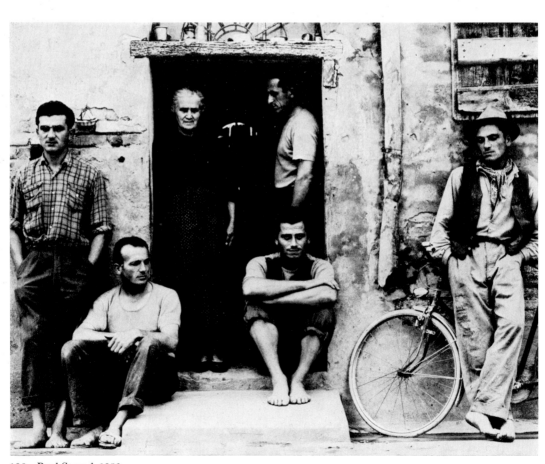

196 Paul Strand, 1953

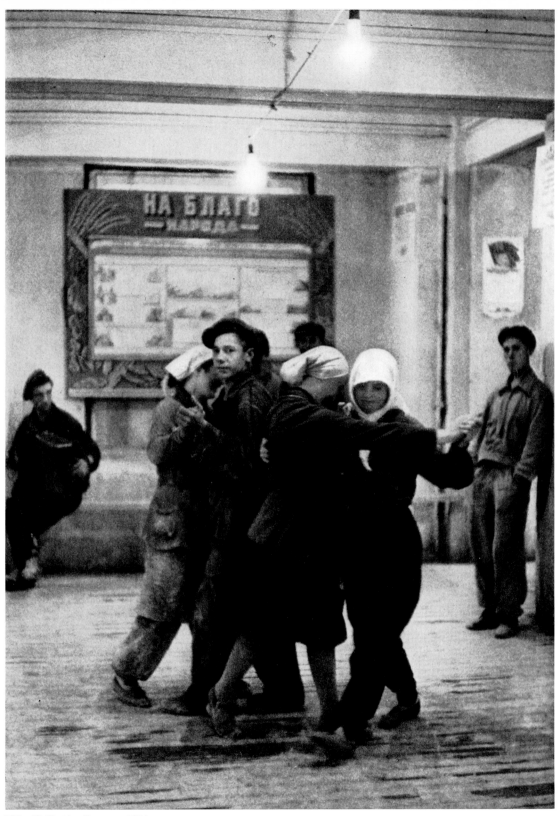

197 H. Cartier-Bresson, 1954

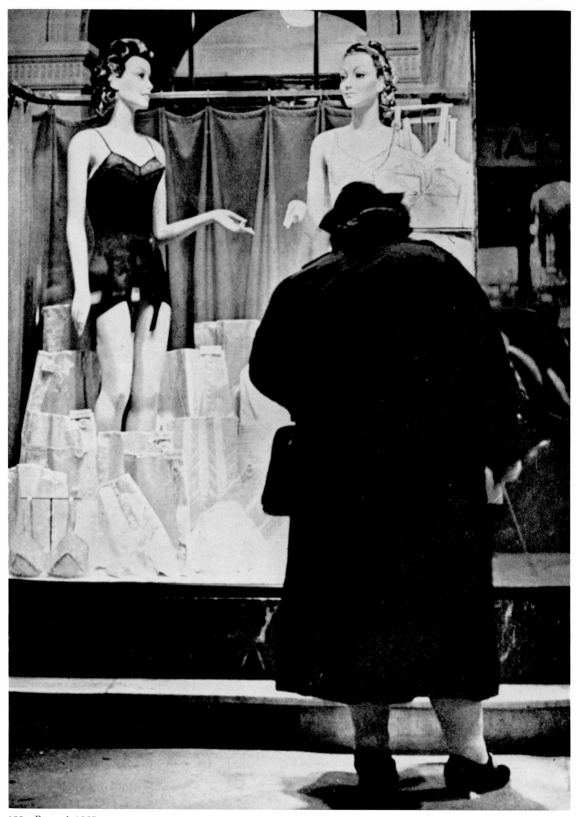

198 Brassai, 1937

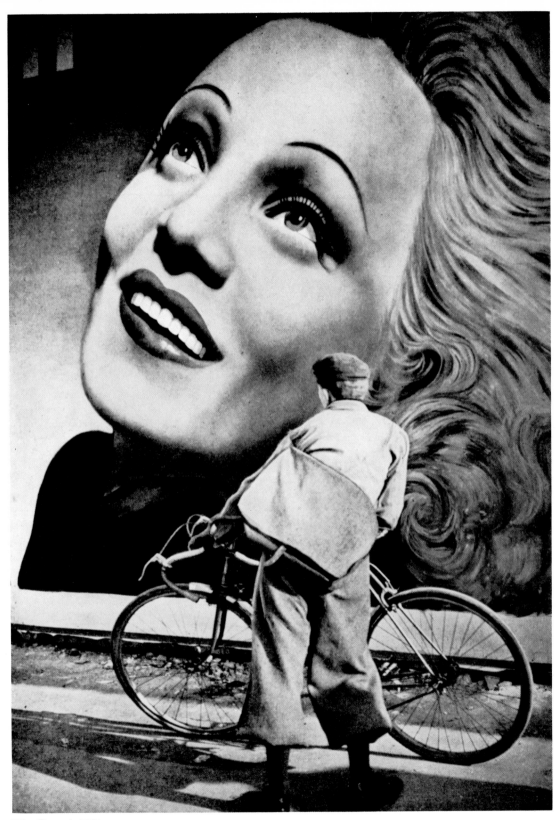

199 Brassaï, 1935

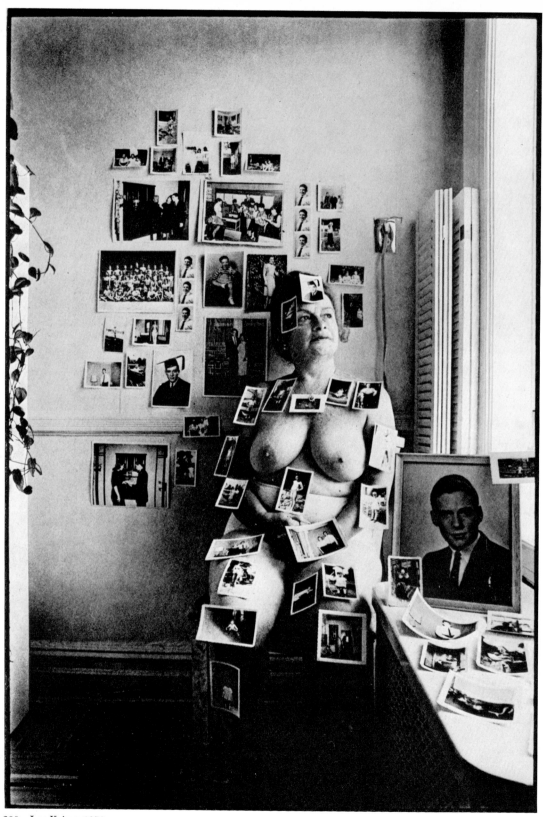

200 Les Krims, 1970

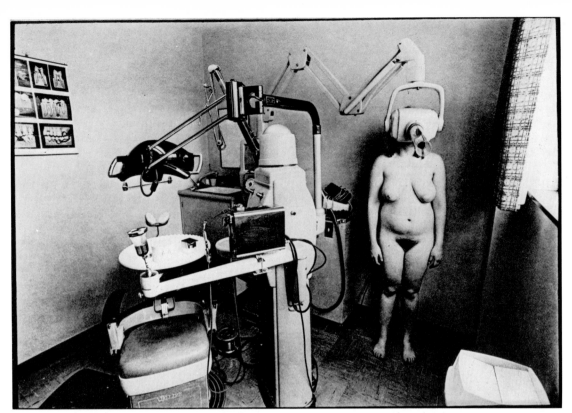

201 Les Krims, 1970

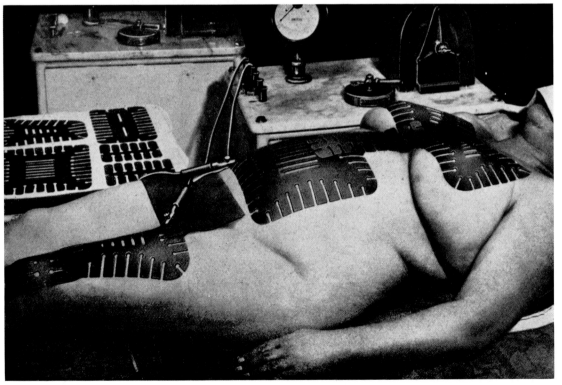

202 Anon., c. 1925

203 Les Krims, 1971

204 Les Krims, 1971

205 David Hockney, c. 1965

206 Diane Arbus, 1963

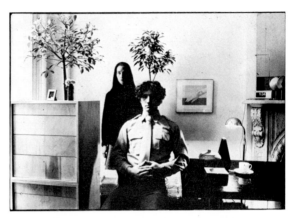
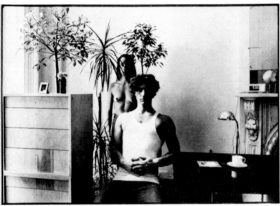
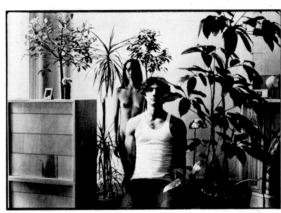
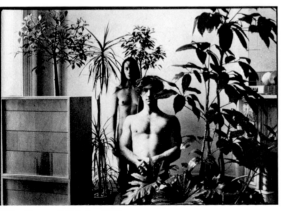

207 Duane Michals, 1968

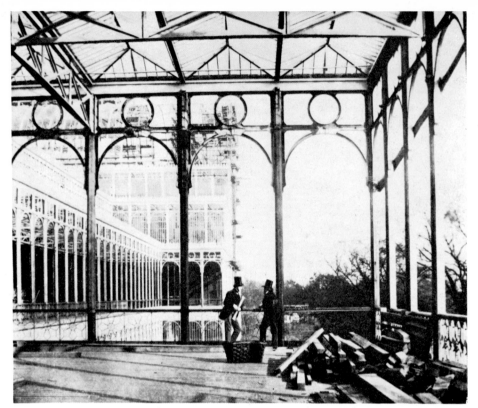

208 P. H. Delamotte, 1853

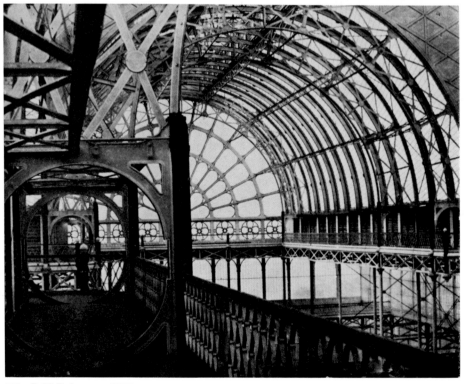

209 P. H. Delamotte, 1853

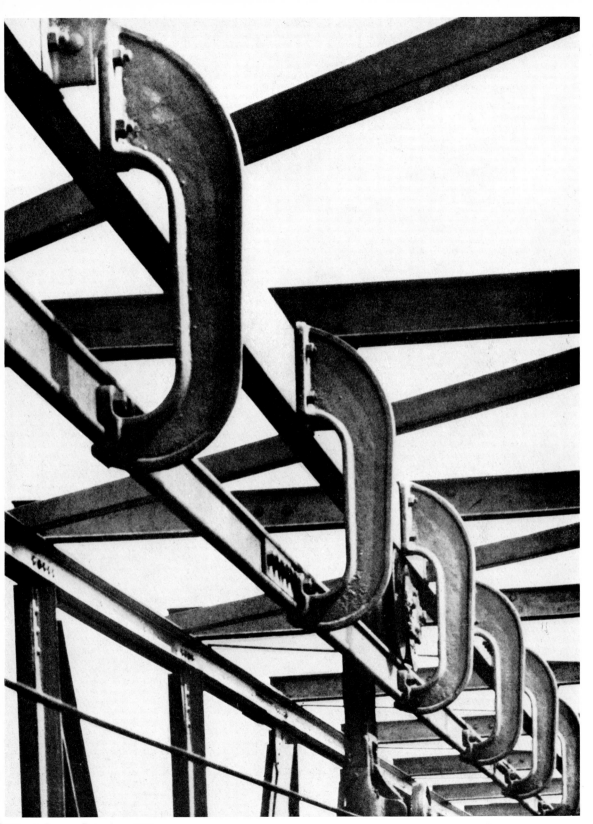

210 A. Renger-Patzsch, c. 1925

211 M. Willinger, 1936

212 Becher, 1963

213 P. H. Delamotte, 1854

214 H. Cartier-Bresson, 1933

215 Russell Lee, 1939

216 Anon., c. 1925

217 Edward Weston, 1941

218 Walker Evans, 1936

219 Edward Weston, 1937

220 Edward Weston, 1937

221 A. Renger-Patzsch, c. 1925

222 Anon., c. 1925

223 A. Renger-Patzsch, c. 1925

224 Anon., c. 1925

225 Becher, 1966

226 Becher, 1967

227 Becher, 1965

228 August Sander, 1928

229 Karl Blossfeldt, c. 1930

Karl Blossfeldt, c. 1930

231 Karl Blossfeldt, c. 1930

Karl Blossfeldt, c. 1930

233 Karl Blossfeldt, c. 1930

234 Karl Blossfeldt, c. 1930

235　Karl Blossfeldt, c. 1930

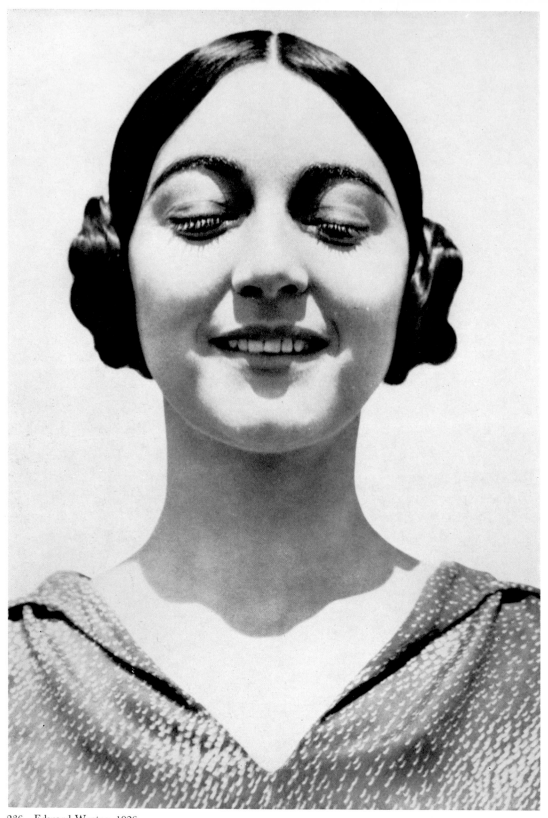

236 Edward Weston, 1926

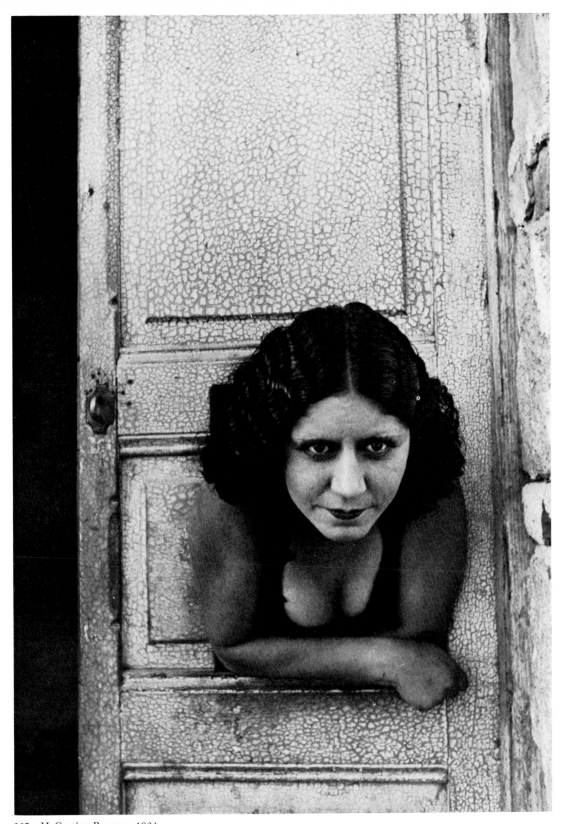

237 H. Cartier-Bresson, 1934

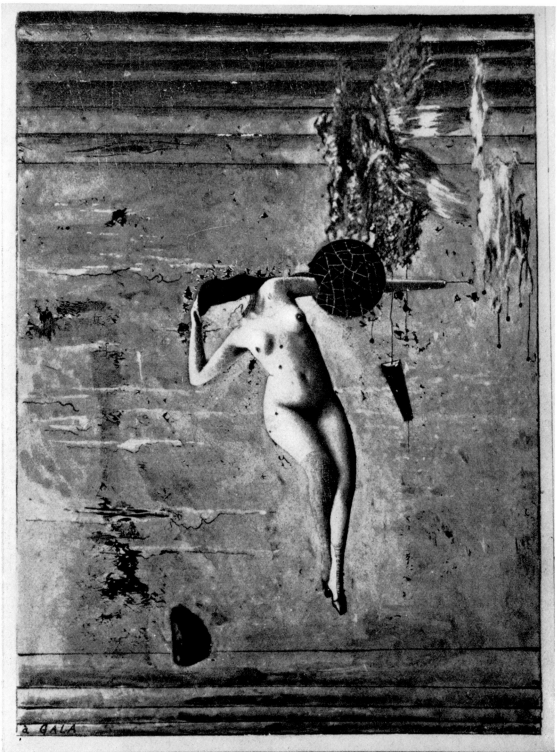

La puberté proche n'a pas encore enlevé la grâce ténue de nos
pléiades / Le regard de nos yeux pleins d'ombre est dirigé vers le
pavé qui va tomber / La gravitation des ondulations n'existe pas encore

238 Max Ernst, c. 1920

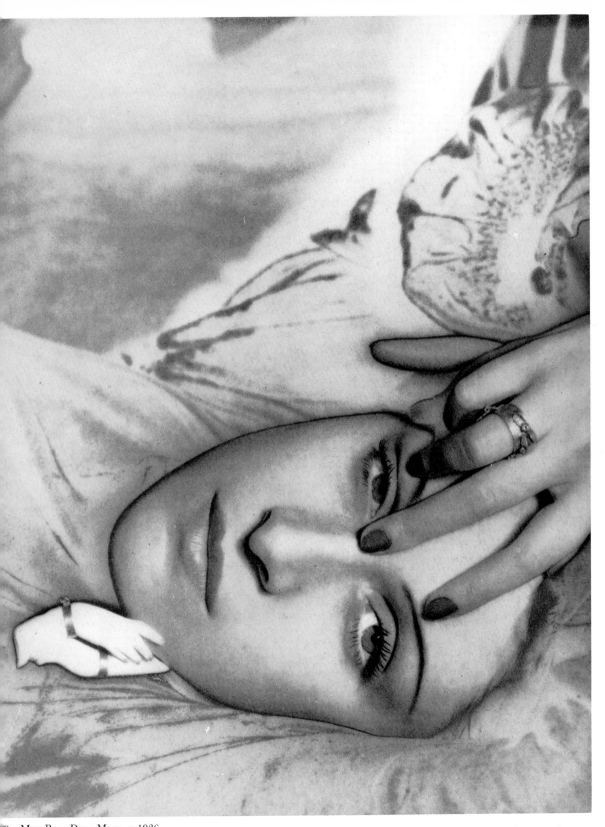

9 Man Ray, Dora Maar, c. 1936

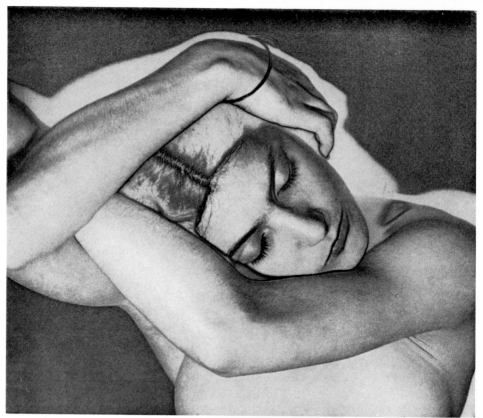

240　Man Ray, 1931

241　El Lissitzky, 1924

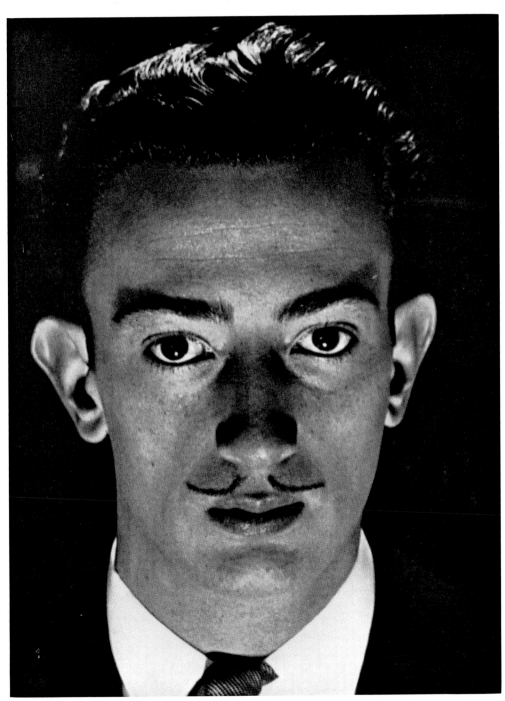

242 Man Ray, Dali, 1936

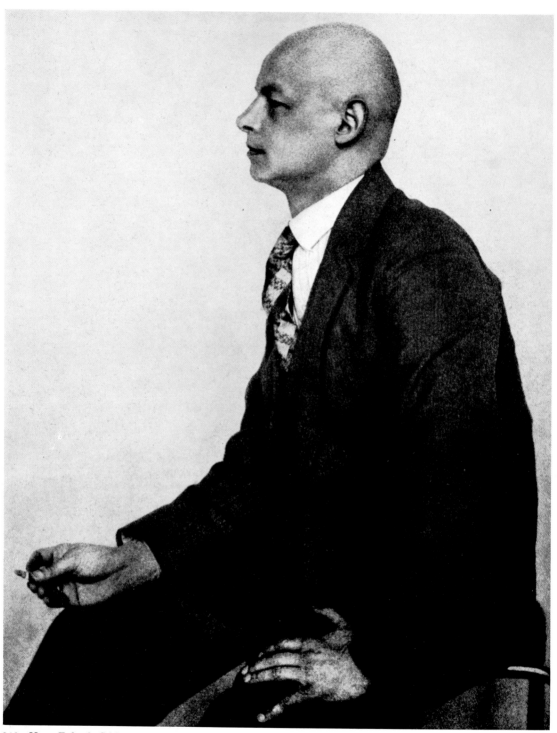

243 Hugo Erfurth, Schlemmer, c. 1925

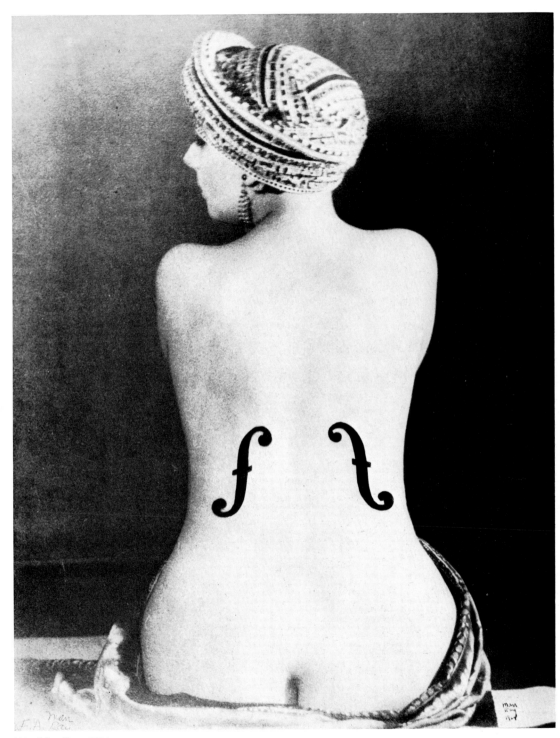

244 Man Ray, 1924

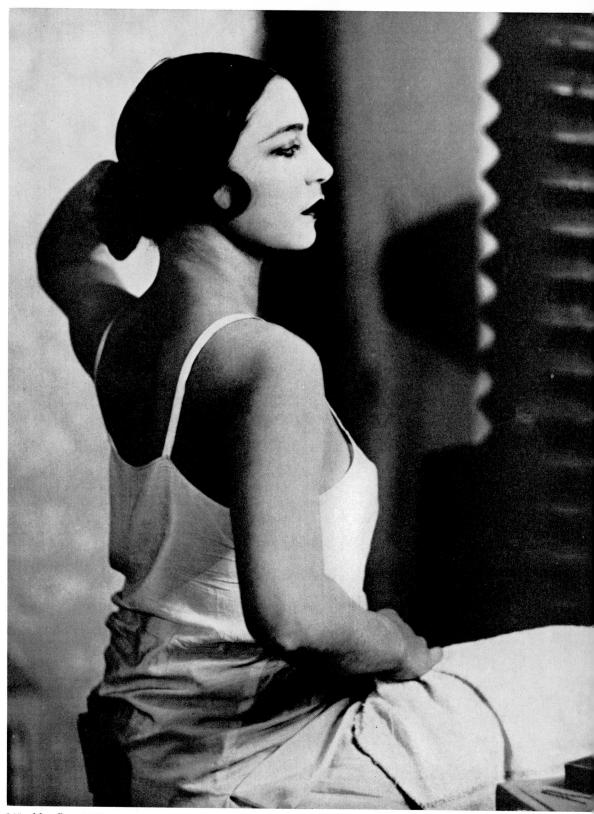

245 Man Ray, 1928

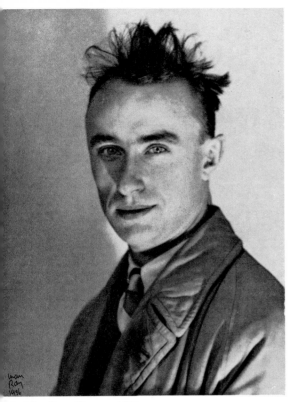

246 Man Ray, Tanguy, 1936

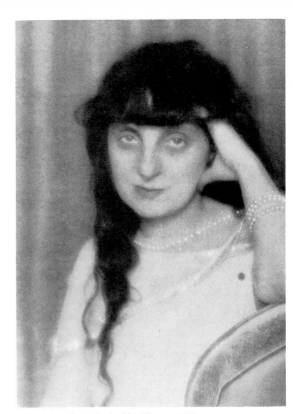

247 Man Ray, A. de Noailles, c. 1930

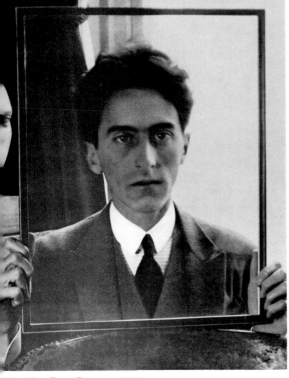

248 Man Ray, Cocteau, 1925

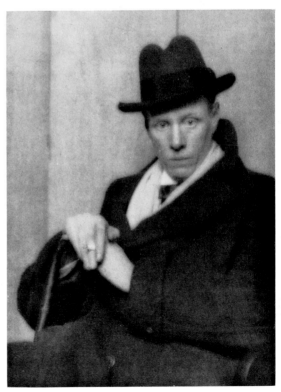

249 Man Ray, S. Lewis, c. 1930

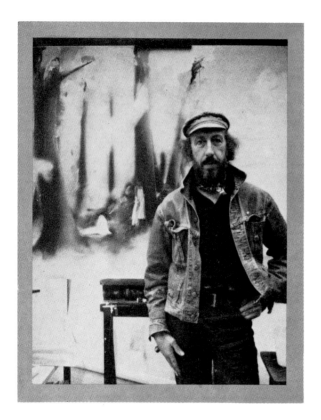

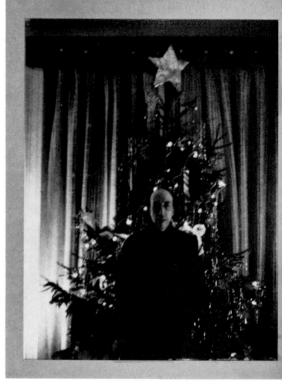

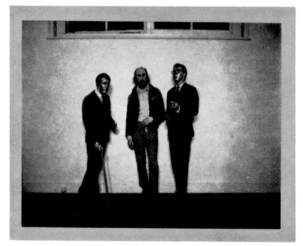

250 Richard Hamilton, 1972 251 Jim Dine, 1968
252 Gilbert & George, 1970 253 Claes Oldenburg, 1969

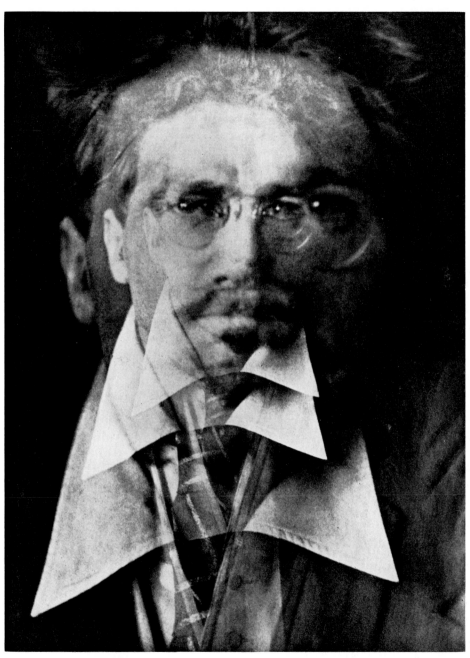

258 A. L. Coburn, Ezra Pound, 1916

259 Eugène Atget, c. 1900

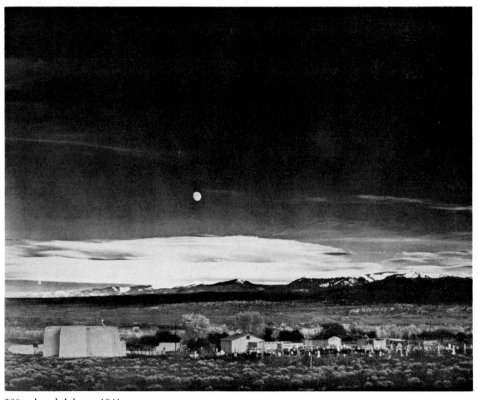

260 Ansel Adams, 1941

162

261 David Hockney, c. 1965

262 Alfred Stieglitz, 1934

263 David Hockney, c. 1965

264 David Hockney, c. 1965

265 Thomas Eakins, c. 1885

266 Brett Weston, c. 1925

267 Brassaï, 1953

268 Paul Strand, 1944

269 Walker Evans, 1936

270 Walker Evans, c. 1931

168

271 Walker Evans, 1933

272 Walker Evans, 1935

273 Wright Morris, 1942

274 Frederick H. Evans, 1903

275 Edward Weston, 1940

276 Charles Sheeler, 1916

172

277 Charles Sheeler, 1914

278 L. Moholy-Nagy, c. 1926

279 Paul Strand, 1915

280 Paul Strand, 1924

281 André Kertész, 1970

282 A. Renger-Patzsch, c. 1925

283　A. L. Coburn, 1912

284 László Moholy-Nagy, 1928

285 László Moholy-Nagy, c. 1930

Walter de Maria, 1968 287 Michael Heizer, 1968

Arnold Newman, M. Graham, 1961

289 A. Renger-Patzsch, c. 1958

290 M. B. Brady, 1865

91 Harry Callahan, c. 1949

292 Lee Friedlander, 1966

293 John Vink, 1972

294 Robert Frank, c. 1950

295 Ralph Gibson, 1970

296 Ralph Gibson, 1970

297 L. Moholy-Nagy, c. 1925

298 L. Moholy-Nagy, c. 1925

299 Lee Friedlander, 1970

300 Harry Callahan, 1949

301 Man Ray, 1918

302 Man Ray, c. 1920

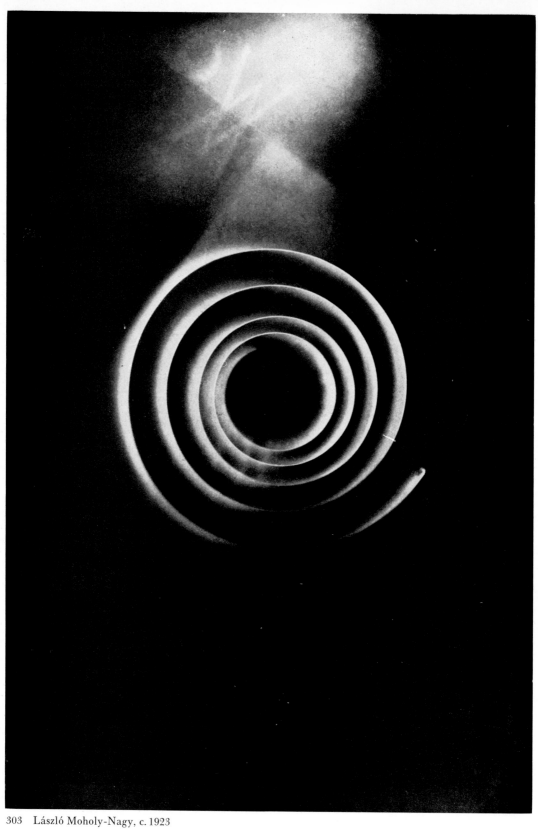

303 László Moholy-Nagy, c. 1923

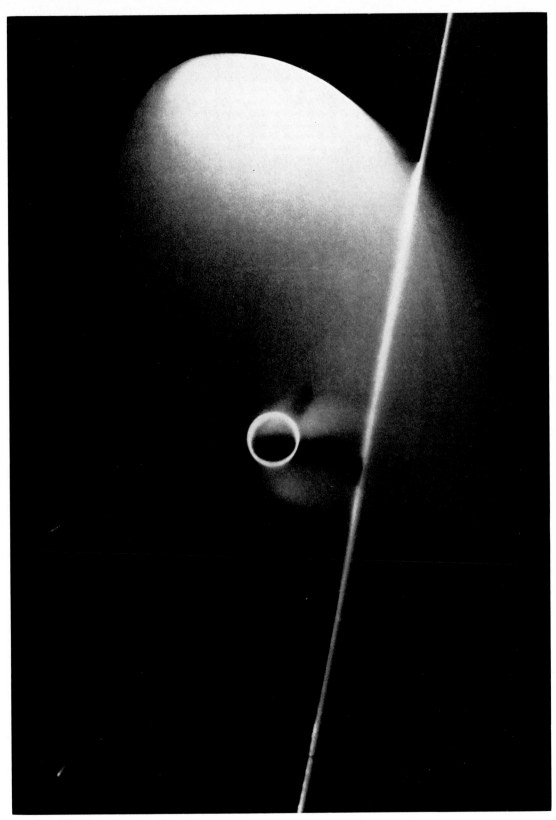

304 László Moholy-Nagy, c. 1923

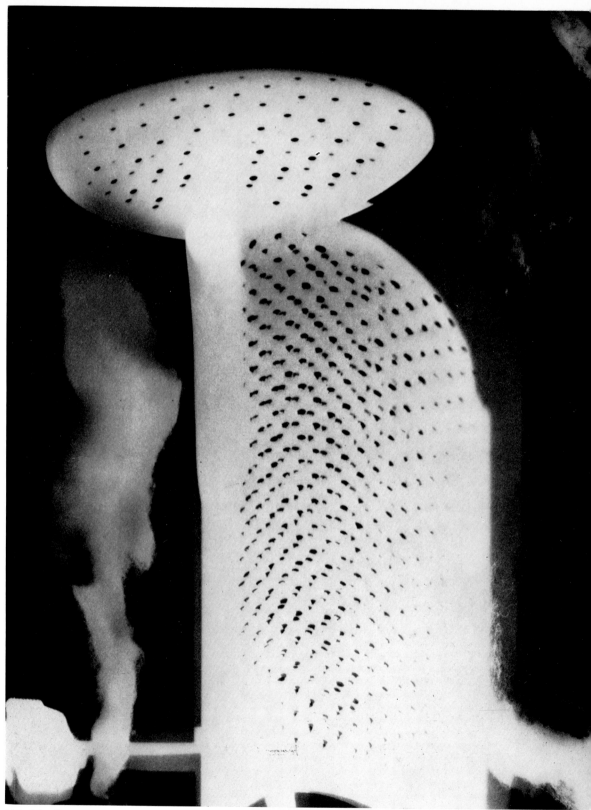

305 Man Ray, c. 1925

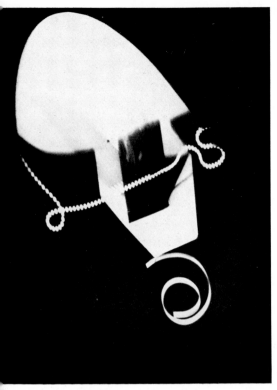

06 Man Ray, c. 1925

307 Man Ray, 1924

08 Man Ray, 1926

309 Man Ray, c. 1925

310 Bruce Nauman, 1967

311 Bruce Nauman, 1966

312 Bruce Nauman, 1967 313 Bruce Nauman, 1967

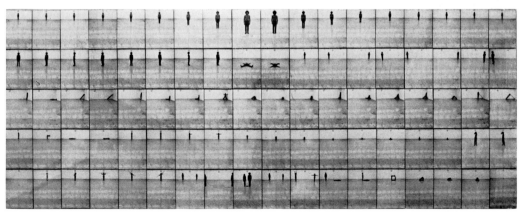

314 Klaus Rinke, 1972

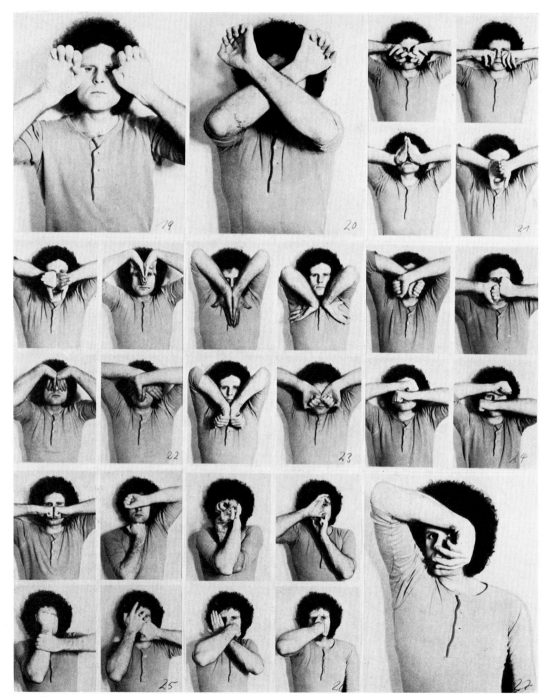

315 Klaus Rinke, 1970

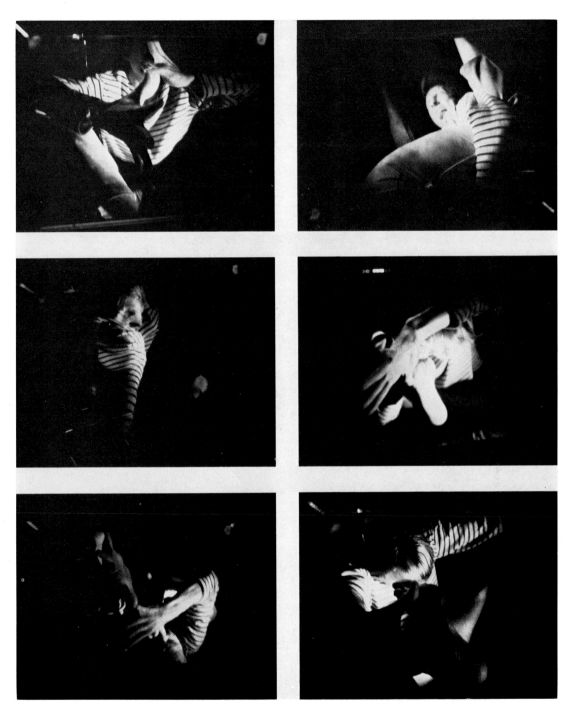

316 Bruce Nauman, 1969

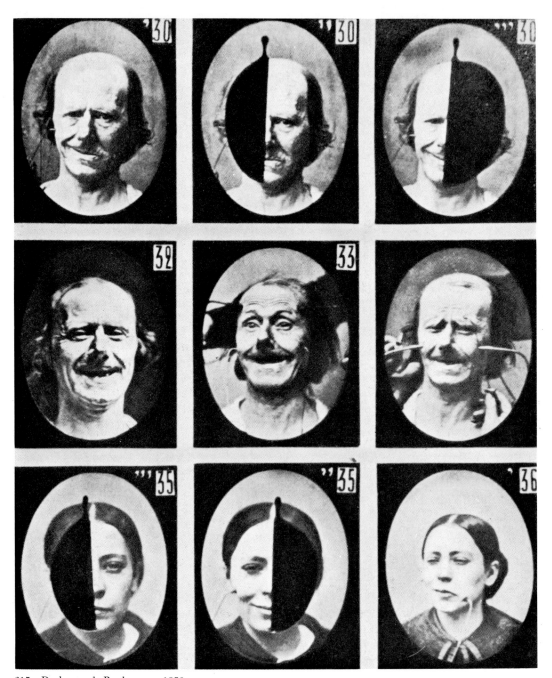

317 Duchenne de Boulogne, c. 1870

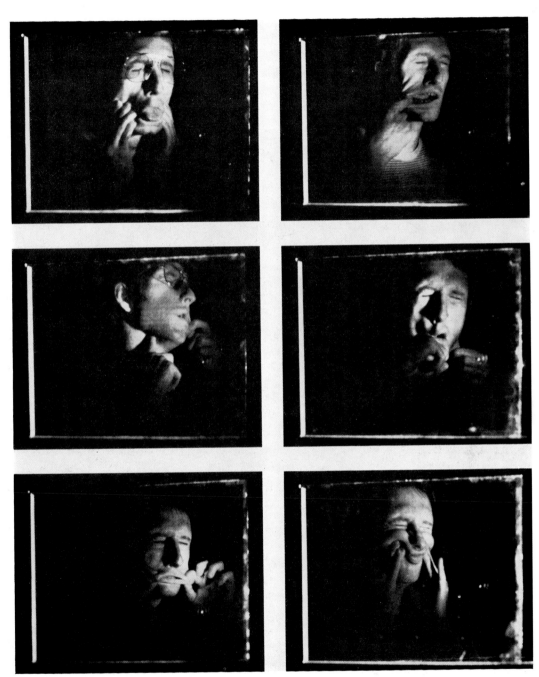

318 Bruce Nauman, 1968

319 Dennis Oppenheim, 1968

320 Robert Petschow, c. 1926

21 Margaret Bourke-White, 1954

322 Anon., c. 1928

323 Anon., c. 1928

324 André Kertész, 1961

325 Ed Ruscha, 1967

326 William Garnett, c. 1950

327 William Garnett, c. 1950

328–331 Ed Ruscha, 1964

332 Bruce Nauman, 1968

333 Hans-Peter Feldmann, 1971

334 Willi Baumeister, c. 1928

335 Gilbert & George, 1971

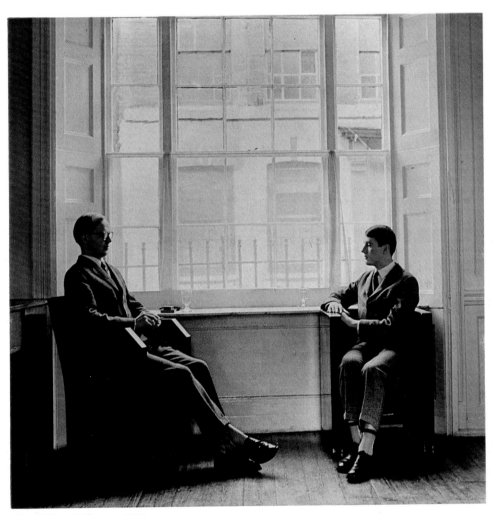

336 Gilbert & George, 1972

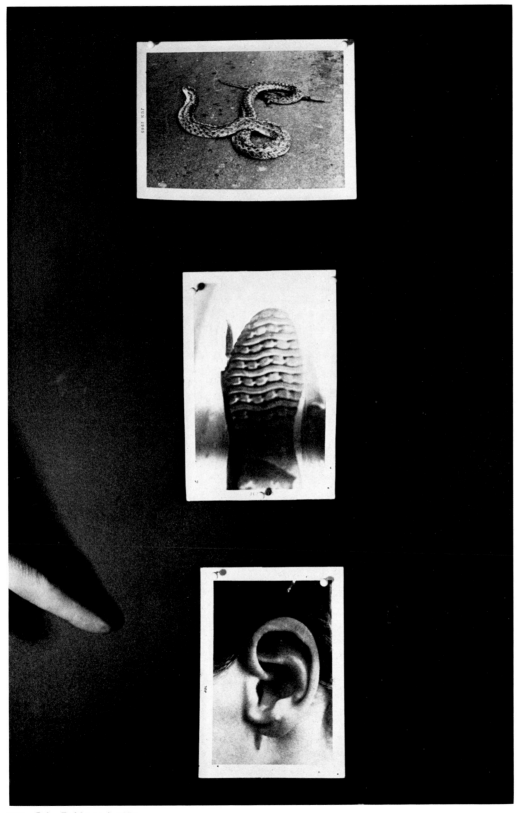

337 John Baldessari, 1971

明治廿六年九月十三日版權所有江崎寫真館三ヶ年間來客中十五ヶ月未滿小兒壹千七百人集寫

338 Anon., c. 1885

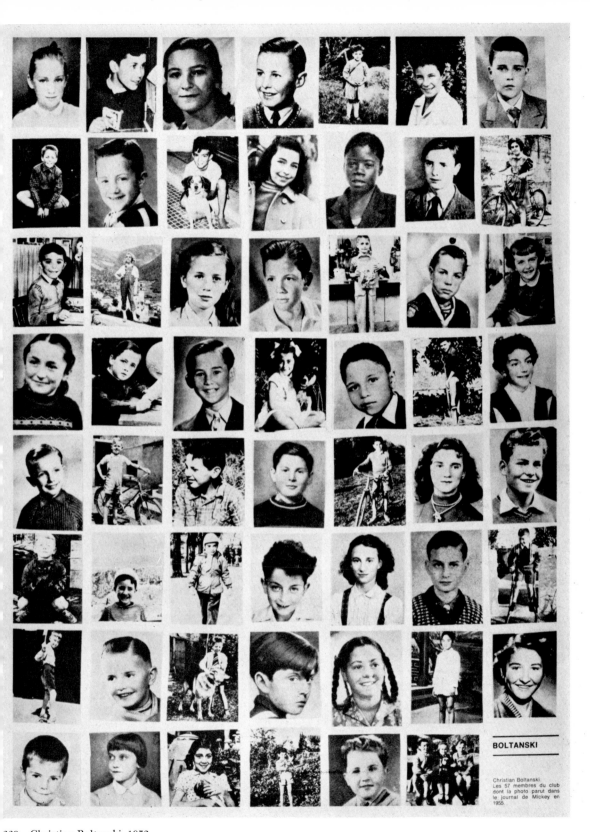

BOLTANSKI

Christian Boltanski:
Les 57 membres du club
dont la photo parut dans
le journal de Mickey en
1955.

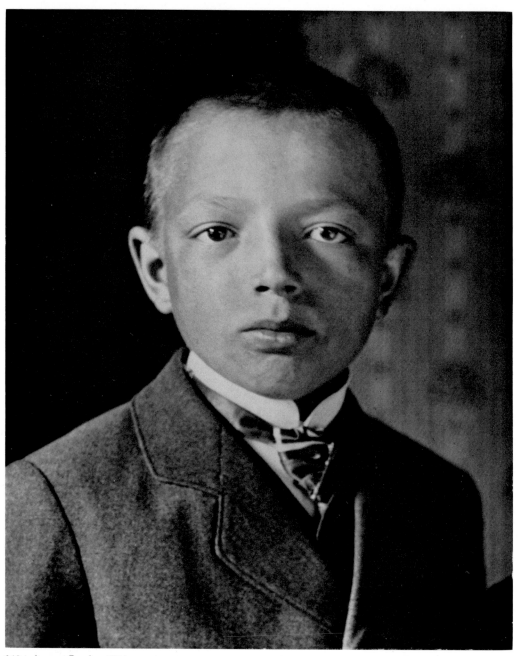

340 August Sander, 1911

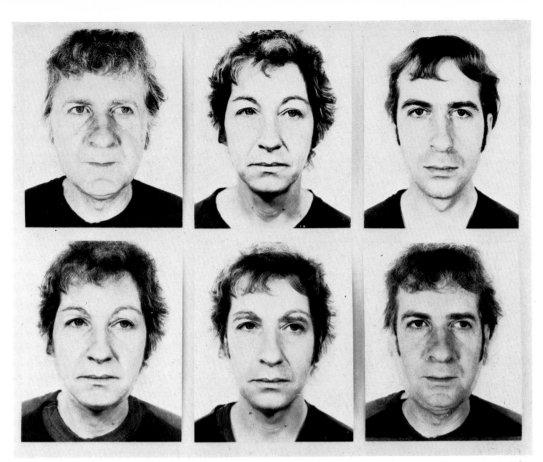

341 William Wegman, 1972

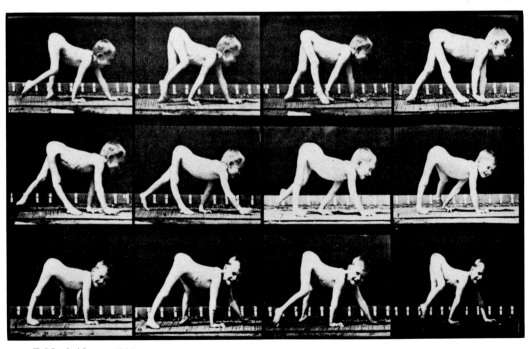

342 E. Muybridge, c. 1885

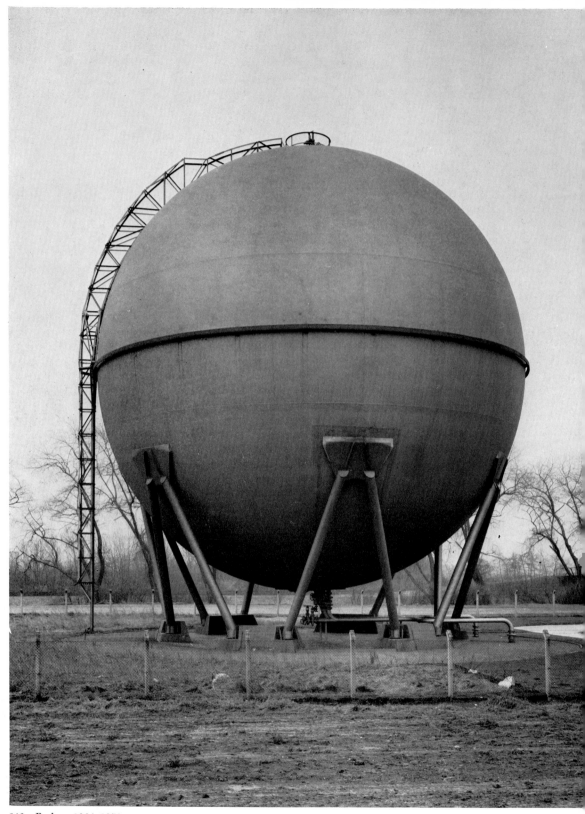

343 Becher, 1964–1970

344 Horacio Coppola, c. 1930

45 Hans-Peter Feldmann, 1969

217

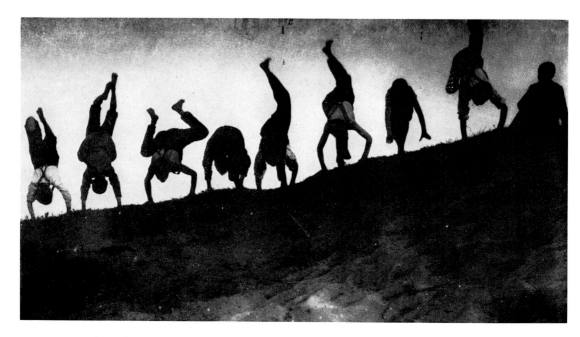

346/347 Heinrich Zille, c. 1910

348/349 Erich Salomon, 1930

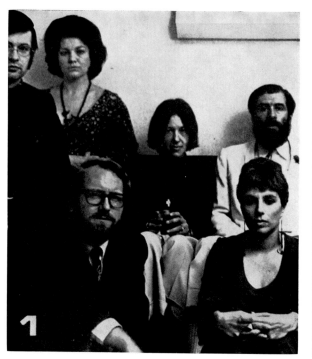

350 Douglas Huebler, 1970

220

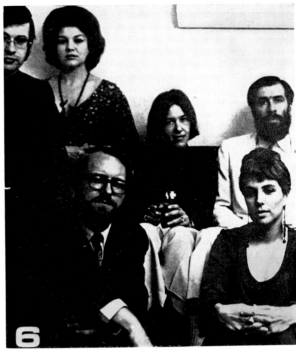

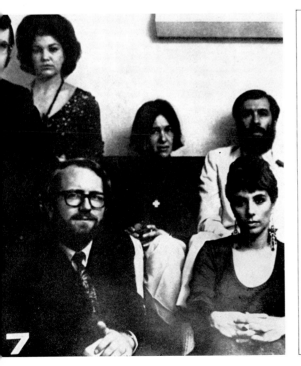

DURATION PIECE No. 14
Bradford, Massachusetts

About 6.00 p. m., for seven consecutive days, (October 5–11), a group of people assembled to have a single photograph made as they assumed nearly the same pose and relative position. They wore, each evening, the same clothes and accessories; even holding similar drinks in order to give the appearance that the photographs had been made in rapid succession during one sitting.

A sign was flashed to the group before each photograph was taken: each person was instructed to think of nothing other than o n e of the two words printed on the sign but in no way to allow that thought to be expressed in his, or her face. The photograph was made exactly 5 seconds after the words were flashed.

The photographs are presented, numbered, in the order that they were made. The words are listed below in no sequential order as they were actually shown to the group by a person other than the artist and their order was not revealed to him.

NOTHING	SCREWING	BIRTH	FREE CHOICE	PEACE	MONSTER	HATE
ANYTHING	EATING	DEATH		WAR	KITTEN	LOVE

Seven photographs join with this statement to constitute the form of this work.

May, 1970 Douglas Huebler

351 Ed Ruscha, 1962

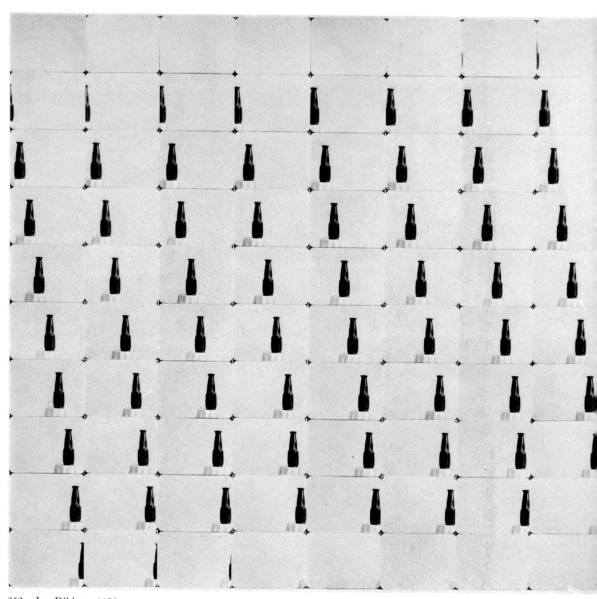

352 Jan Dibbets, 1972

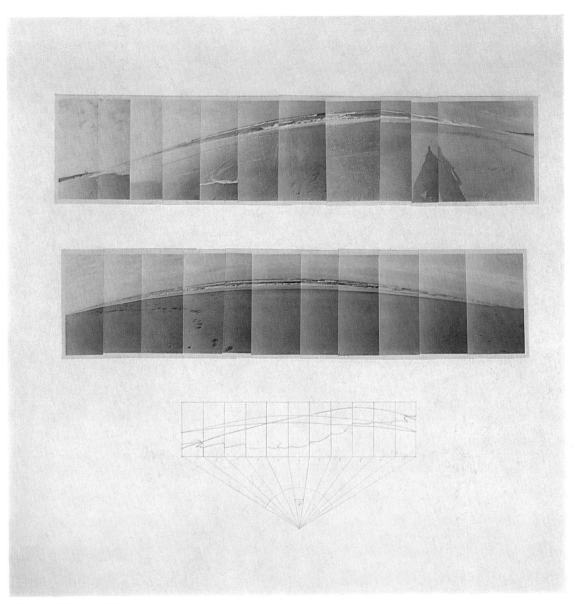

353 Jan Dibbets, 1971

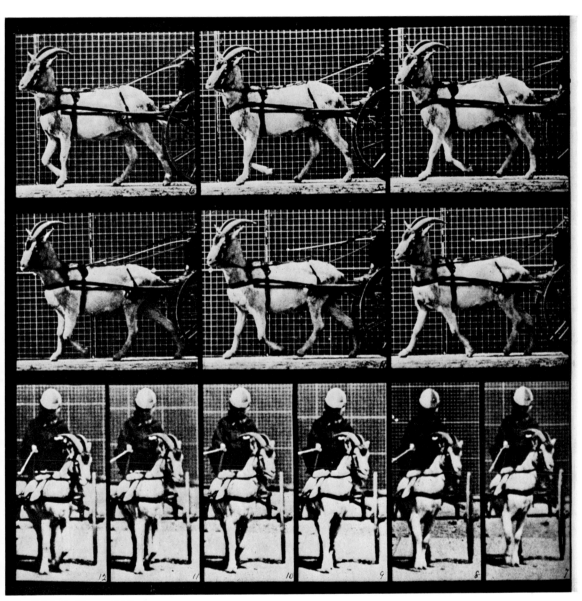

354 E. Muybridge, c. 1885

355 Becher, 1959–1963

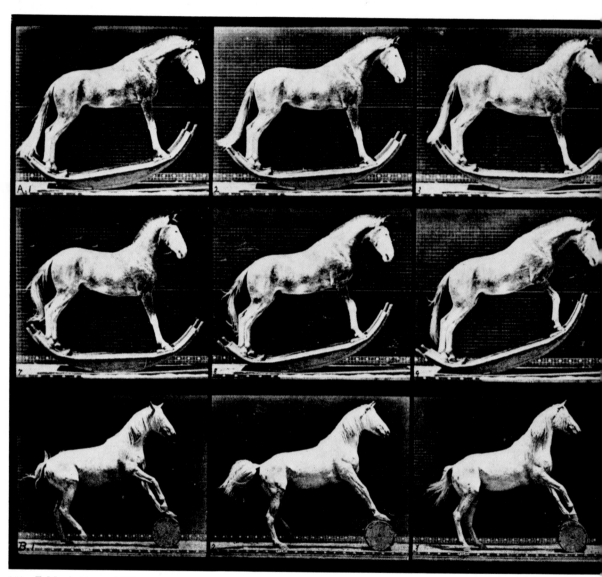

356 E. Muybridge, c. 1885

228

/358　William Wegman, 1970

/360　William Wegman, 1971

361/362 Lothar Baumgarten, 1971

363/364 Hamish Fulton, 1971

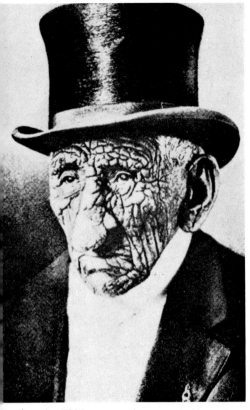

 Anon., c. 1925

366 Anon., c. 1925

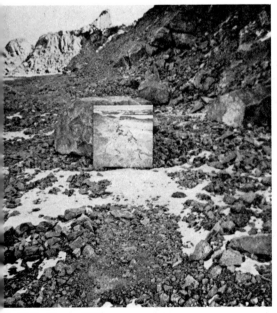

7 R. Smithson, 1968

368 R. Smithson, 1968

369 Hamish Fulton, 1971

370 Hamish Fulton, 1971